ART + LiFE
CoMbINed

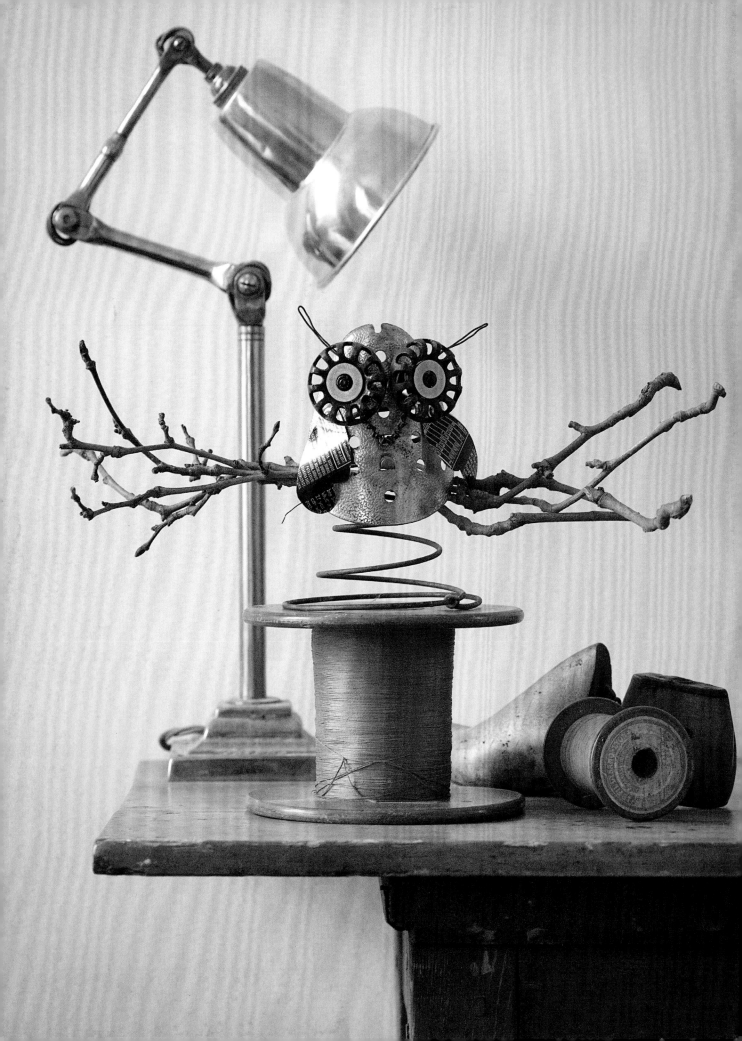

ART + LiFE COmbINed

35 mixed media projects to inspire your **INNER** artist

Linda Peterson

CICO BOOKS
LONDON NEW YORK

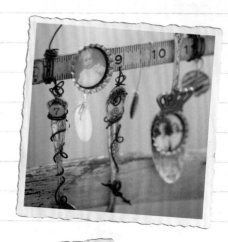

Published in 2012 by CICO Books
An imprint of Ryland Peters & Small Ltd
20–21 Jockey's Fields,
London WC1R 4BW
519 Broadway, 5th Floor,
New York, NY 10012

www.cicobooks.com

10 9 8 7 6 5 4 3 2 1

Text © Linda Peterson 2012
Design and photography © CICO Books 2012

The author's moral rights have been asserted. All rights
reserved. No part of this publication may be
reproduced, stored in a retrieval system, or transmitted
in any form or by any means, electronic, mechanical,
photocopying, or otherwise, without the prior
permission of the publisher.

A CIP catalog record for this book is available from the
Library of Congress and the British Library.

ISBN: 978 1 908170 91 0
Printed in China

Editor: Marie Clayton
Designer: Mark Latter bluedragonfly-uk.com
Step-by-step photography: Geoff Dann
Style photography: Gavin Kingcome
Styling and art direction: Luis Peral-Aranda
Template illustrations: Stephen Dew

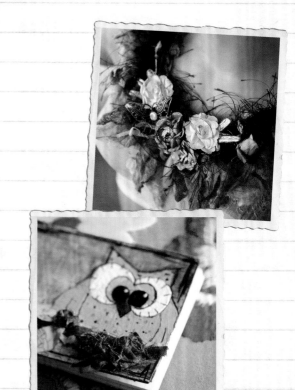

For digital editions, visit www.cicobooks.com/apps.php

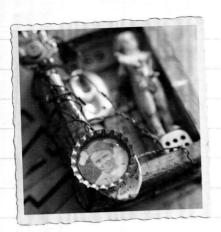

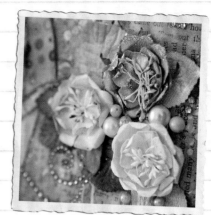

CoNtEntS

INtrODUCtiON

Art + Life Combined—I thought a lot about the title of this book, it took me days to finalize it. I chose it for two reasons: First, ART is my soul, it's a way of expressing emotions, it's a respite in an unkind world. Second, inspiration is all around us and I believe that you are an artist—you just have to discover your talent and realize that sometimes it might be hidden under many layers of LIFE.

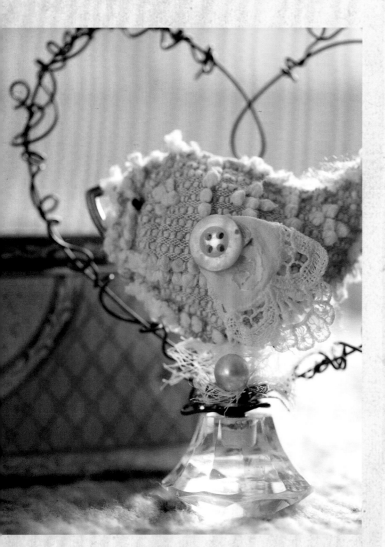

I have lived a very creative life. Sometimes, I used my creative resources to work through difficult moments, family illnesses, or simply raising my children. Yes, like you, I have experienced all of the above—and while I have used my creativity to problem-solve and cope with those challenges, I have also used it to express my feelings through art in many forms.

I have been a professional artist for 20 years, but the reality is I've been an artist all my life. I recently discovered many hand-made cards and letters that I had given to my Mom and Grandma—carefully drawn flowers and garden scenes generally graced their covers. I hand-designed Barbie doll clothes with my Grandma when I was eight years old. And even though those designs are childlike in form, they unleashed my inner artist and prepared the way for me to do what I love to do later in life: make art!

I grew up in a family that loved to "dumpster dive." The phrase "one man's trash is another man's treasure" was one we lived by. I'm proud of that. I am proud that I can look at something —nearly anything—and see some hidden potential… its inner beauty, despite a harsh outer appearance. And when that "something" is given a fresh new life, it thanks me with its beauty. I attach memories to objects. Looking at them reminds me of good times, the memories of who I was with when gathering such junk. It's my happy place.

I believe this book to be so much more than just a book filled with things to make. I designed it to inspire you, to teach you techniques of how to see the potential in objects you might otherwise toss away, to use your personal experiences and encapsulate them in your own designs, to dig down deep and unleash the artist that is within you. I think that when you unlock your inner

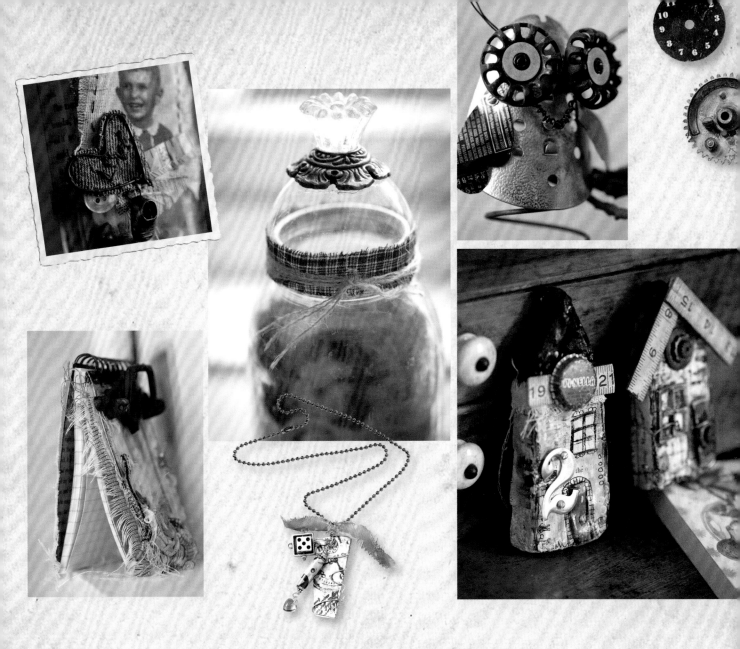

creative soul, you'll find that you are writing your own personal history through art.

Before you go off on your creative journey, let me please offer this piece of advice. Don't stress yourself out if your artwork doesn't turn out as planned. Your art doesn't have to be pretty; no one has to like it but you. You will most likely have failures and flops in your art, but work through those just as you work through challenges in life. We don't give up in life, and we don't give up in art. If it's any consolation, almost all of my art goes through an ugly phase where I want just to give up and pitch it in the bin! But when I keep on working with it through to the finish, almost always I am delighted with the outcome. Knowing what works and what doesn't opens up whole new worlds of exploration and

possibilities. So relish and delight in the creative process; many times it can ultimately be more rewarding than the actual finished piece.

So now, enjoy your artistic discover, unleash your inner artist—and may you find peace and happiness every day of your creative life.

INspIrAtION

I am quite often asked, "How do you come up with your ideas?" and "How do you know what to do with them?", followed by, "I wouldn't know where to begin!" The answers to those questions really provide the stepping stones you will need to create mixed media art that is very personal to you and truly your own.

The key to finding inspiration is in training your eye to see things for more than what they really are, and your ear to hear more than what is being said. I believe it's important to have some "alone time" set aside each day—or at minimum, each week—to allow your thoughts to flow. Take this time for a walk (maybe even take a camera with you) and take in all the sights and sounds of nature. Stop for a moment, close your eyes and soak in the sounds, feel the wind, smell the flowers, stare at all the luscious color and textures that surround you. Take lots of pictures of texture, colors, butterflies, birds—really anything, no matter how small, can be a source of inspiration. Take note of sizes, colors, textures, and shapes and how these relate to one another. Nature is the perfect teacher of composition, too!

Instead of a literal walk, why not take an inspirational walk without leaving your home? Peruse magazines—especially colorful ones, like garden and bridal magazines—take a virtual trip reading a travel magazine about a dream destination, or simply flip through old photographs and let your mind recollect special memories of times gone by.

I try to have a small notebook handy to jot down thoughts or memories that cross my mind or to sketch a particular idea—nothing fancy, just something to remind me of the thought at any given moment. I also keep an inspiration journal of photographs I've taken from nature, or bits and pieces I've cut out of a magazine. I separate them into color palettes and texture palettes. I also cut out artwork that I feel is creatively inspiring and add it to this journal. I use this inspiration journal to jumpstart my projects.

Maybe you are thinking, "these ideas are great, fine and dandy, but how do I translate them into a piece of artwork?" Ahhh, yes, great question—this is where your trained eye comes into play. As an example: take a look at the Birdcage on page 100. I took inspiration from a musical birdcage belonging to my Grandmother Ruth; I remember the little song that it played when you wound it up. It is that childhood memory that made me want to create a birdcage reminiscent of that moment in time. So with that inspiration in mind, I asked myself, "What do I have that is round and would make a suitable base?" A used CD came to mind—the perfect size and shape! What some might see as a used computer CD, I saw as a great base for my birdcage.

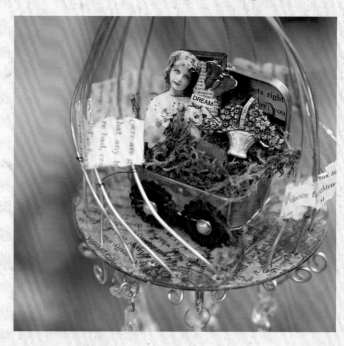

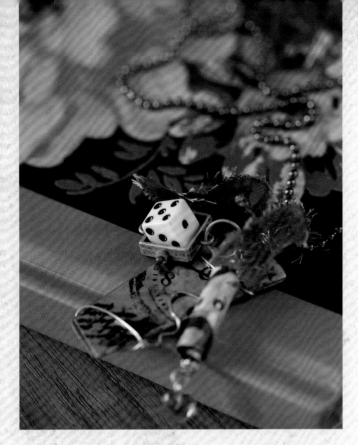

For another example: look at the Carnival Ride necklace (see above). It is a symbolic rather than a literal translation of inspiration and also symbolizes the idea of the young love between my parents when they first met and dated in the '50s. I used bright colors to symbolize playfulness; a dice, because sometimes life is "a roll of the dice" and you deal with what comes your way; a piece of ribbon to add a bit of texture and represent the free spirit of youth; the heart, a symbol of their love that lasted over 50 years. These objects, used in this way, symbolically allow you to see them for something other than what they are.

Give yourself permission to let your mind wander and allow random thoughts to flow in and out of your brain. Then take the "thought" that stands out the most and translate it. Ask yourself these questions: "What texture most represents this thought?", "How does this 'thought' affect my emotions and what color would I use to attribute to it?", and—if the thought is of a specific object—"What do I have that is a similar shape that can be repurposed?"

Remember, colors can have a huge impact in expressing feelings and emotions. Red is often associated with love and bright colors with happiness, while the dark, gloomy colors can express sadness.

Textures, too, can play a part in symbolically in expressing our creative thoughts. Heavy, thick textures can often symbolize deep thoughts, difficult moments, and perhaps sadness, while lighter, more airy textures can convey quite the opposite—happy, cheerful, playful, and fun. By utilizing these few basic techniques, you'll begin to see things in a whole new way and a whole new world of possibilities will open in front of your eyes!

PRinCiPlES Of dEsIgN

Without getting too complicated and technical, I want to share with you a few composition and design concepts that will help you in creating your own art from scratch.

Elements of composition and ways to add interest

Subject matter does matter, because it is what we visually respond to. Your art will become your story and the subject matter or elements that you choose to put into your art will provide all the details related to telling your story. Elements can make or break the story you are trying to convey. Using the principles of design and composition is also a way to express visual grammar; the way in which we use these principles helps us to come up with our unique style and way of conveying ideas in our artwork.

When working with design I often use the "rule of thirds"—see the diagram below. There is much to be learned about this rule and if you search the Internet, you will find loads of very helpful information. It lends itself to composition. Note how the diagram is divided into nine equal spaces, three vertically and three horizontally. By placing the focal area of your artwork either one third across, or one third up or down, or on the lines that intersect, you will create a pleasing arrangement and add visual interest to your art.

Harmony, unity, and balance

These are equally important: elements that add complementary layers to the piece create harmony and result in a more attractive piece of artwork. When nothing distracts from the artwork, you have achieved unity. You can also create a visual interest by incorporating contrast or opposition. This can be done, for example, by combining a softer element with one that appears harsh—maybe a fabric that is light to the touch combined with one that is heavy and has a bold pattern, for example.

Balance is also important to take into consideration. Your artwork can be symmetrical—in other words, the same on both sides—or asymmetrical, which is where the focal area is slightly off to one side or the other, and at times may even fall off the side. I find working with asymmetrical designs more casual and relaxed.

Odd numbers versus even numbers

This also has to do with harmony and variety. Typically when I introduce a shape, element, or color, I repeat it three or five times in the piece in a variety of sizes or color values and sprinkle it about. This creates variety, visual harmony, balance, and more interest in your art. Odd numbers work better for composition than even numbers, such as two and four. They just look better.

Adding depth and visual textures

You'll notice that, throughout this book, I add lots and lots of layers. Whether it's color over color, texture over color, or elements applied to the top, all of this creates layers of depth and visual interest. I like to think of it as inviting your viewer back for more, to see something new.

Certainly these are by no means every principle of design rule or technique, but they are the ones that I use most often and find the most helpful. Feel free to experiment and develop your own personal style and design.

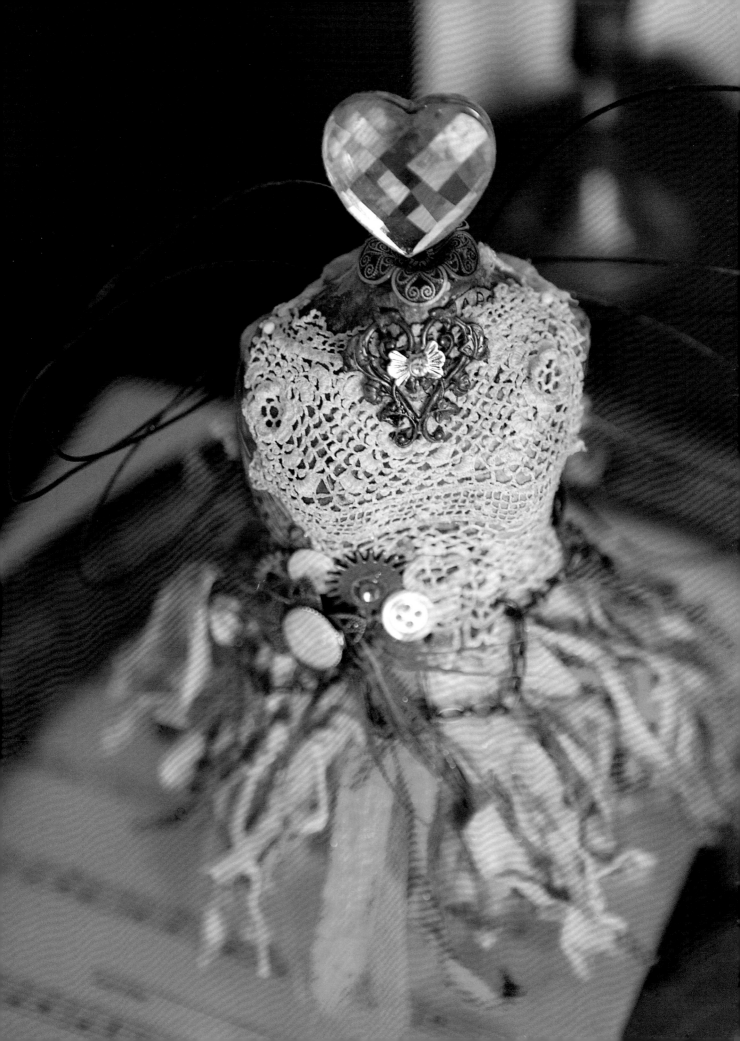

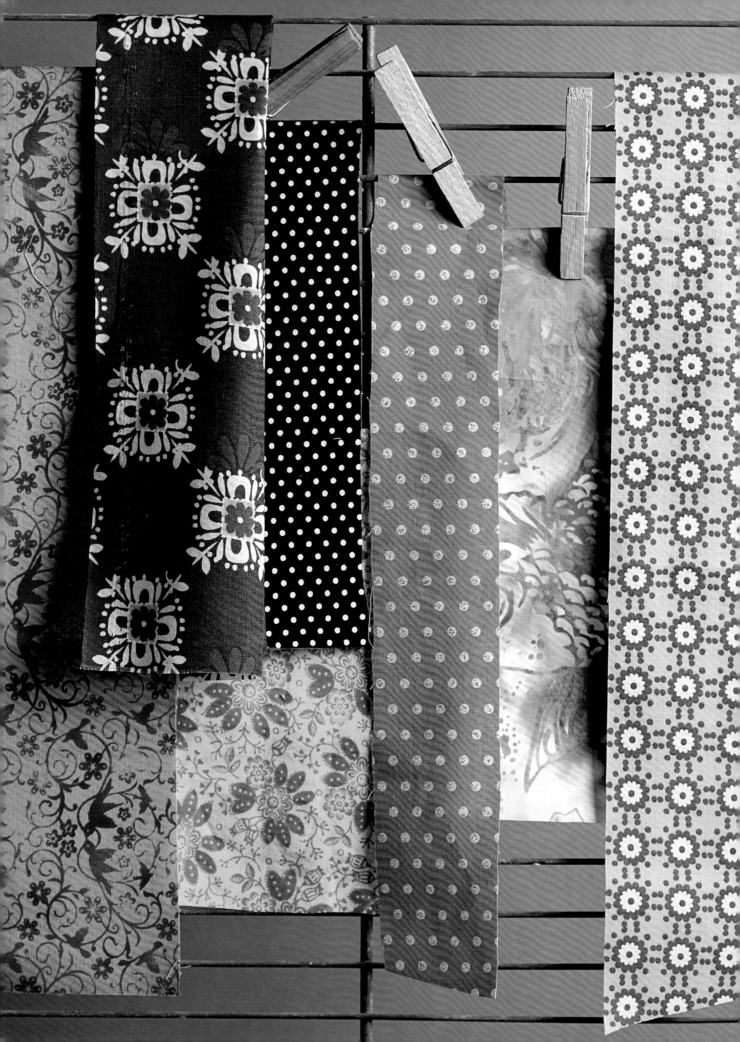

TOOLS, MATERIALS, aNd TecHNiQUeS

In this first section you will find most of the practical information that you will need to get started. But don't worry if you just want to dive in and start making something—all the projects include a list of the tools and materials you will need upfront, and cross references in the steps back to any basic techniques in this section, so you can just look things up as you need them.

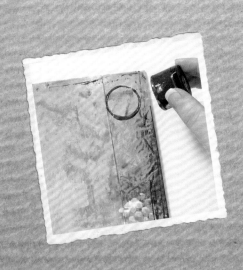

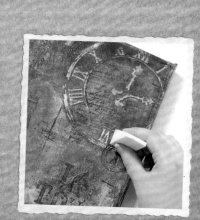

T⦿ol⫷

One of the great things about mixed media is that in most cases you don't need any special tools—you can manage with what you probably already have around the home. However, for a few projects in this book there are slightly more specialized tools that will make things quicker and easier. I have detailed some of these below.

PLIERS AND WIRE CUTTERS

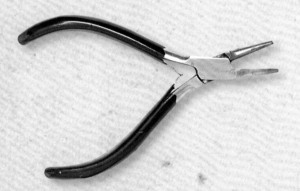

Concave bending pliers
Allow you to easily bend wire when forming it into rounded shapes to create loops when wire wrapping. I prefer these to the more common round-nose pliers, because they grip the wire better.

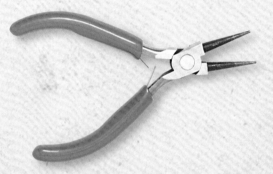

Round-nose pliers
Often used to create loops and rings in wire, or when creating decorative coils. The jaws are tapered so you can create different-sized loops and rings.

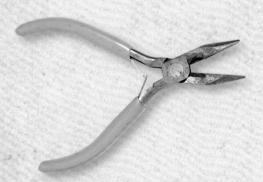

Basic jewelry pliers
Can be used to grip wire when bending it or to hold small objects as you work on them. These generally have a serrated surface to the jaws so you can grip wire tightly—be careful, as this may damage softer materials.

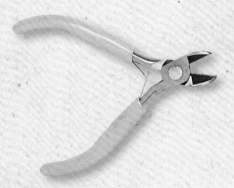

Wire cutters
Standard wire cutters cut wire into a pointed end, the flush-cutting type create a flat end. Either type will be fine for the projects in this book. You can sand any sharp edges away with sandpaper.

CUTTING AND SEWING TOOLS

Hole punch
To create small holes, there are different types of punch available to pierce different materials; they also come in a variety of sizes and shapes.

Scalpel/craft knife
Ideal for clean, straight cuts in paper and thin cardstock and for trimming edges neatly. Use with a metal rule—the blade may damage a plastic one—and protect the work surface with a cutting mat. Don't forget to keep your fingers out of the way, too!

Scissors
Mainly used to cut fabric, paper, and thin cardstock, but the heavier-duty types will also cut through thin metal and plastic.

Drill
For drilling holes in metal, wood, and other hard materials. For metal you may need special metal drill bits, unless the material is very thin and soft.

Needles/Curved needle
The basic sewing in these projects can be done with an ordinary sewing needle—although you may need one with a larger eye if you are stitching with embroidery floss (thread). The curved needle is handy when stitching across an inflexible surface.

Bradawl or center punch
For marking holes before they are drilled—the tiny dent made by the tip helps the drill bit locate in place without slipping.

COLORING AND TEXTURING TOOLS

Pot lids
Dip lids into paint and stamp onto the surface where desired to create circles. Vary the pressure to create distressed circles. A perfect circle isn't always necessary or desirable.

Paintbrush and fine-line marker
Paintbrushes come in all sizes and shapes, depending on how you want to apply paint or adhesive. The fine-line marker is ideal for outlining and adding final detail.

Texturing items
Many everyday items can be used to create texture with wet pigment, such as drawer liner (top), woven materials (center), or the corrugated interior of packing cardboard (bottom).

Cosmetic sponge
These are triangular in shape, so they have sharp edges and tips as well as flat surfaces; they are useful for smoothing color across an area, or applying tiny areas of color.

Brayer
To roll over flat items or large stamps to transfer texture or color evenly. Can also be used to smooth down glued paper to remove any air bubbles.

MISCELLANEOUS TOOLS

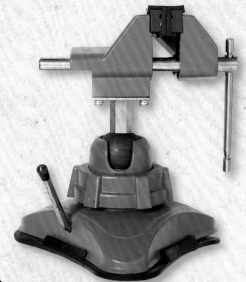

Hammer
An ordinary hammer from a toolbox is fine— useful for flattening metal or setting eyelets.

Vise
The vise is used to hold small pieces when cutting or drilling—the type shown here has a head that can hold items at different angles.

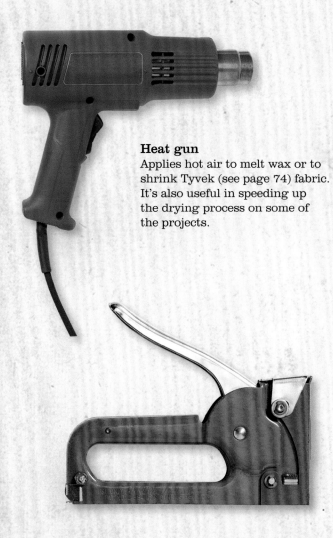

Heat gun
Applies hot air to melt wax or to shrink Tyvek (see page 74) fabric. It's also useful in speeding up the drying process on some of the projects.

Flexible mold
Many designs are available, for molding thermoplastic, polymer clay, fibercast plaster, and other malleable materials to create 3-dimensional shapes.

Heavy-duty stapler
For fixing layers together quickly and easily. The staples can be removed—although this may leave a hole. I like to use staples as they add an interesting industrial look to projects.

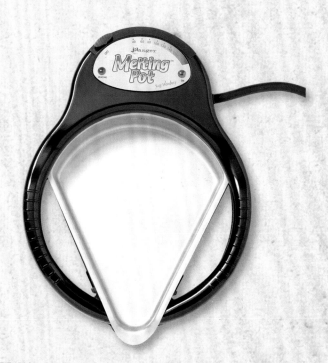

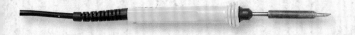

Soldering iron
For soldering metals with a low melting point. It is used with plumber's solder to join metal components together permanently. The solder can be found at a local hardware (DIY) store and can be used with copper or brass. Flux will help the solder to flow smoothly and to go where you want it.

Melting pot
For melting thermoplastic, wax, and other heat-sensitive materials.

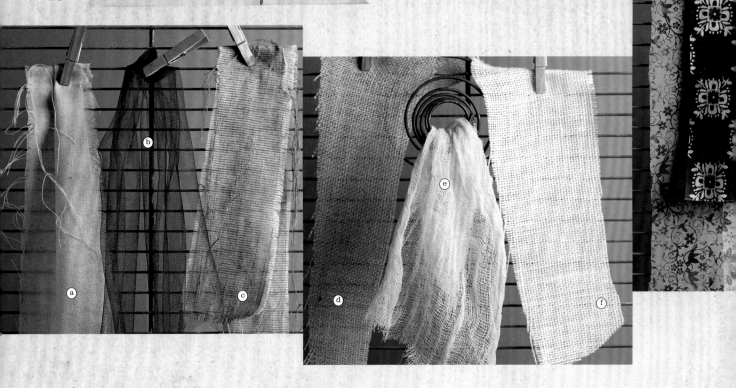

MATeRiAlS

So many ordinary, everyday things can be used for mixed media projects. This section shows a few of the materials used for the projects in this book, but it is by no means exhaustive and you certainly don't have to have the exact same materials to complete your projects. Use this section as a springboard and look around and see what else you have that you can use to create your artworks.

FABRIC AND THREAD

a. Muslin (calico)
An inexpensive material that takes dye really well and is great for many different uses. It's also ideal to paint or stamp on.

b. Tulle
This type of fabric is like stiff netting; because it is very fine and open in construction, it is translucent and ideal for softening shapes. It is available in several colors as well as plain and glittery.

c. Woven cotton
A type of coarsely woven cotton that will unravel along its cut edges, so is perfect for creating frayed decorative effects. Also consider using fabrics salvaged from worn-out clothing.

d. Burlap
A coarsely woven natural fabric, sometimes also called sacking, that also frays well and has a wonderful texture.

e. Cheesecloth
An inexpensive fabric that takes dye or other types of color really well and also frays nicely. It is ideal for many different uses, and can even be coated with adhesive to make molded shapes.

f. Coarse weave linen
A stiffer material than either cotton or cheesecloth, with an attractive even weave—again useful for adding texture as well as color.

g. Printed fabrics

Printed fabrics come in a wide variety of designs and colors. The base fabric is usually finely woven cotton, which takes the color well and allows the detail of the design to show clearly.

h. Textured fabrics

These are either woven with a textured design, or the texture has been introduced by stitching or quilting onto a base fabric. They can be used to introduce texture to your designs; some types can also be used as a stamp to create texture prints in wet pigment (see page 26). Instead of looking at the pattern, consider the texture of the material. Quilting scraps and chenille are excellent examples of what to look for.

i. Trims

Trims can be used in many, many different ways, and there is such a wide variety available that they really can add a unique look to your artworks. Trims with long, feathery, floating elements introduce movement, while beaded trim adds some sparkle. Trims can be sourced at your local craft store, but I really enjoy finding vintage trims at antique or flea markets.

j. Plastic fabrics

Plasticized fabric, woven plastic, and plastic sheet are all used extensively in commercial packaging such as for feed sacks. Quite often the outer printed design can be utilized, but often the reverse side is plain white. This is where it's important to train your eye to look beyond the obvious and notice textures and weights of fabric.

Thread

Sewing thread (below left) and embroidery floss (thread) (below right). Most sewing threads can be used for hand or machine sewing. The embroidery floss is worked by hand and gives a more defined stitch.

COLORING AND MOLDING

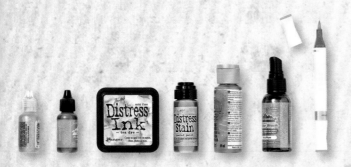

Inks and markers

There are many different types of craft inks and paint available; water-based types are easy to dilute for different effects. Distressing ink can be used to give new items a vintage look. Alcohol-based inks are useful for coloring, since they dry quickly and are transparent.

Thermoplastic

This can be melted into a malleable form for molding; it is also available in granule form.

Gesso

A type of paint primer, used to create a base surface that will take paint particularly well.

Mounted canvas (not shown)

Available in many sizes, use these to create 2-dimensional artwork. For our projects we paint a background or decoupage a base layer to the surface before creating the main artwork. Group several canvases on the same theme together to create a large piece of wall art.

ADHESIVES

Jewelry adhesive

This is the best adhesive to use when gluing beads to the surface.

Tape

Double-stick tape is not very attractive, but it is quick and mess free for holding things in place, as long as it will not show in the final item.

Craft adhesive

A general-purpose adhesive that comes in different formulations for different materials and uses. For the majority of our projects, we used thick tacky glue.

Jewelry and metal adhesive
A cyanoacrylate glue formulated for use with metal findings and other metal pieces. Use in a well ventilated area.

Two-part epoxy adhesive
A strong adhesive that will harden to create a strong bond after the two parts are mixed together.

Decoupage medium
Acts as both an adhesive and a sealant when creating decoupage.

METAL COMPONENTS AND FINDINGS

Chicken wire
An inexpensive twisted metal mesh that is ideal for creating 3-dimensional shapes and to add a rustic touch to your projects.

Wire
19-gauge/0.9mm annealed steel wire (above left), 24-gauge/0.5mm copper wire (above top) and 24-gauge/0.5mm non-tarnish silver wire (above right). Annealed wire is softer and can be cut with standard wire cutters. We use wire a lot as a decorative element and as a fastener.

Chains
Chains come in countless sizes, designs, and materials. Odd scraps of chain left over from jewelry or other craft projects can often be utilized in mixed media artworks.

Metal pieces
A selection of miscellaneous metal objects that are used in many decorative ways in the following pages. Anything that has an interesting shape can find its place in mixed media work.

Findings
A selection of jewelry findings that can be used to make your artwork into a wearable piece. They are easy to find in your local craft store, or can be bought online.

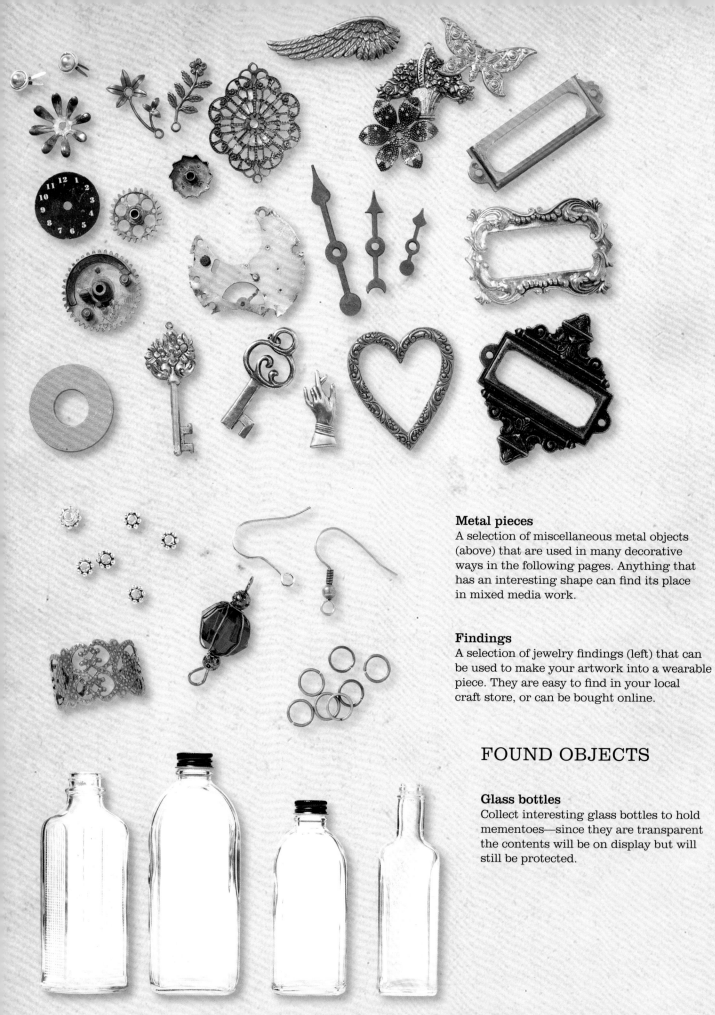

Metal pieces
A selection of miscellaneous metal objects (above) that are used in many decorative ways in the following pages. Anything that has an interesting shape can find its place in mixed media work.

Findings
A selection of jewelry findings (left) that can be used to make your artwork into a wearable piece. They are easy to find in your local craft store, or can be bought online.

FOUND OBJECTS

Glass bottles
Collect interesting glass bottles to hold mementoes—since they are transparent the contents will be on display but will still be protected.

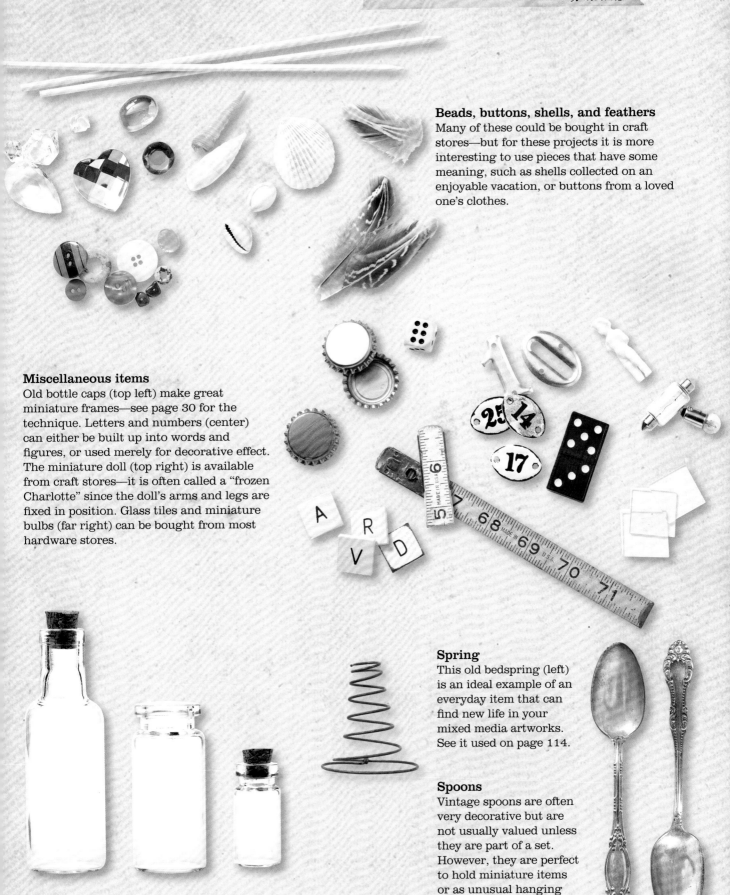

Beads, buttons, shells, and feathers

Many of these could be bought in craft stores—but for these projects it is more interesting to use pieces that have some meaning, such as shells collected on an enjoyable vacation, or buttons from a loved one's clothes.

Miscellaneous items

Old bottle caps (top left) make great miniature frames—see page 30 for the technique. Letters and numbers (center) can either be built up into words and figures, or used merely for decorative effect. The miniature doll (top right) is available from craft stores—it is often called a "frozen Charlotte" since the doll's arms and legs are fixed in position. Glass tiles and miniature bulbs (far right) can be bought from most hardware stores.

Spring

This old bedspring (left) is an ideal example of an everyday item that can find new life in your mixed media artworks. See it used on page 114.

Spoons

Vintage spoons are often very decorative but are not usually valued unless they are part of a set. However, they are perfect to hold miniature items or as unusual hanging elements—see page 111.

Small vials and jars

Small vials and bottles are perfect when creating artworks in miniature.

MOLDING MATERIALS

Polymer clay
A synthetic clay (below left) made from PVC plastic, which remains very soft and pliable until baked in a home oven. The softer types are easier to work initially, but when baked are not as strong as the firmer variety.

Papier mâché
Ready-made paper fiber (below top center), which is mixed with water according to the directions on the package to make a paper pulp that can be molded. It dries to a light but strong 3-dimensional shape.

Molding paste and popsicle sticks
A semi-liquid paste (below right) that can be smoothed over a stencil with a popsicle stick to create a raised design.

Stencil
Plastic stencils (below) can be used with paint to create a colored design, or with the molding paste to create a raised design.

PAPER AND CARD

Stickers, card, CDs, tags, resin stickers
Rub-on sticker shapes (opposite page, top left) can be pre-printed in color or as outlines so you can color them yourself, while an old CD is an ideal base for a circular shape. The type of cardboard (opposite page, center) used in many projects has a flat sheet top and bottom with a fluted center filling—it is sometimes called corrugated fiberboard and is generally used to make packing cartons. Tags (opposite page, top center) can be used in many ways—I find them ideal to try out mixed media ideas. Printed cardstock (opposite page, far right) is stiffer than paper, so may be better for a particular project. Clear resin sticker dots (opposite page, top right) are great for sealing images into bottle caps—they are sometimes also called page pebbles.

Printed papers and photographs
Old newspapers, book pages, and music sheets (opposite page, bottom) are great for découpage—if you use photocopies, they can be aged with distressing ink. Don't use original photographs in your artworks—copies are easily made.

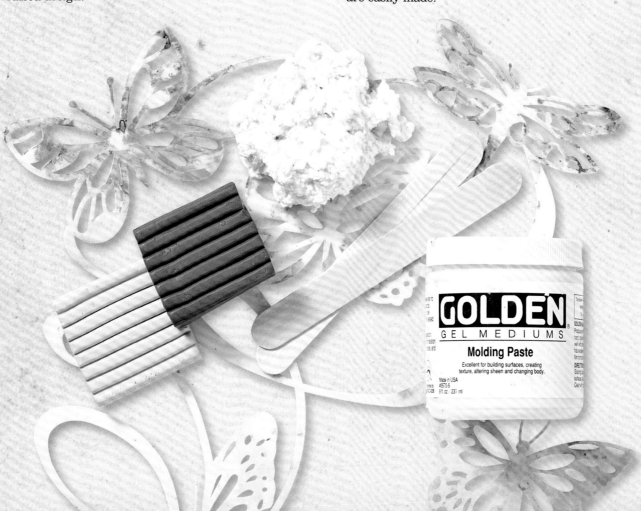

GOLDEN

GEL MEDIUMS

Molding Paste

Excellent for building surfaces, creating texture, altering sheen and changing body.

Made in USA
8 fl. oz. / 237 ml

TEchNiQuEs

With each new project, I try to introduce you to something new. A few techniques are used over and over again in many of the projects in this book, so they are gathered together here for easy reference. Where they are required in a specific project, a cross-reference will bring you to the correct page in the techniques section.

CREATING A BACKGROUND

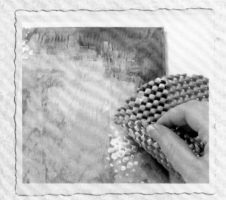

Creating texture Build up a base color on your background material. Press different objects into the surface to create texture; here a drawer liner sheet is used to create a gingham look. Other ideas include using bubble wrap, burlap, shelf liner, or doilies.

Stamping straight lines The edge of an old credit card is ideal to stamp fairly short, straight, distressed-looking lines. You can use the side for a short line and the base for a longer line. Vary the pressure for a more random effect.

Creating circles Bottle or jar tops are great for creating circles. Since they are easily available in many different sizes, you can quickly build a good selection. Other objects include pencil ends or the end of a spool of thread; look for objects with an interesting pattern.

Adding text Rubber stamps are a quick way to add text. You can make it appear distressed just by adjusting the pressure as you apply the stamp, which will add extra interest. You could also simply write the text using a fine-line marker.

Adding fine detail A fine paintbrush or a fine-line permanent marker can be used to add detail in selected areas. The paintbrush has the advantage that you can vary the line weight to get exactly the effect you need.

HElPFuL HiNT

My suggestion is that you schedule some playtime and allow yourself some creative free time to explore these techniques and discover some more of your own. Save the backgrounds—even your ugly ones—for future projects. Remember there are no flops, just flopportunites!

TEA DYE

For small pieces of fabric, such as muslin or cheesecloth, simply make up some hot tea and dip the fabric into it, allowing it to soak up the dye. For larger pieces, use a large, shallow dish. Let the fabric dry flat.

SPRAY DYE

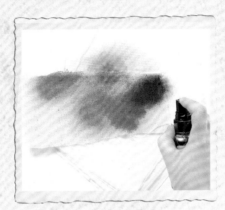

1. Choose a water-based wash dye and spray color directly onto the fabric or paper. You can protect the surface underneath with a stack of paper towels or napkins.

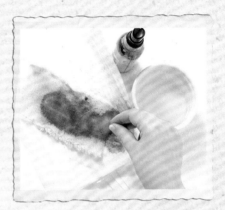

2. Dip the tips of your fingers in a bowl of clean water and dab droplets onto the dyed area to create the intensity of color you want, or to create a mottled effect.

CRACKLE GLAZE

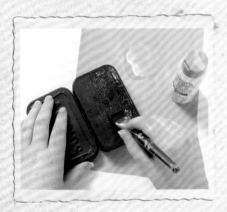

1. Paint the outside of the item in a base coat of your chosen color and allow to dry completely. Paint over this with a generous layer of crackle glaze and allow to dry.

2. Paint with the top coat of contrast color and again allow to dry—the crackle glaze will crack this top coat as it dries, revealing the base coat underneath.

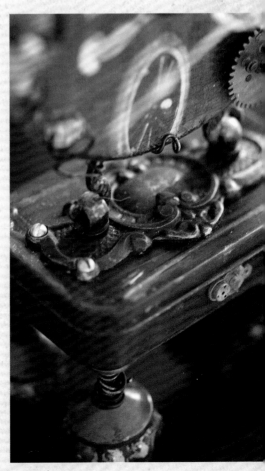

DRAWING AND COLORING A FACE

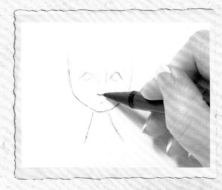

1. Draw the outline of the face and neck with a vertical line down the center. Add a horizontal line about halfway down to indicate the eyes and divide the space below into thirds to indicate where the tip of the nose and the mouth will be.

2. Be sure to draw guide lines lightly so that they can be erased later. Draw a circle for the eyes. Lightly draw in the side of the nose. Draw half-moon shapes over the eyes for eyelids

3. Draw a slightly curved line for the shape of the nose. It's okay if you need to erase at any point and try again. Just try not to erase lines you are already happy with.

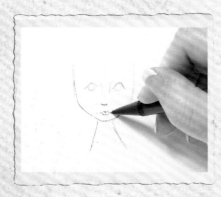

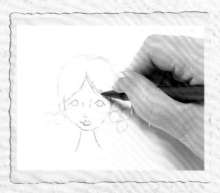

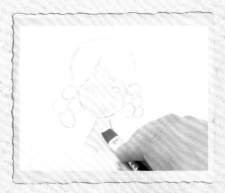

4. Add the bow shape of the upper lip, and then put in the curve of the lower lip.

5. Begin roughly drawing in the hairline and the curls of hair on either side of the face. The expression is now beginning to take shape.

6. Add a wash of a pale flesh tone over the entire face and neck, but avoiding the hair.

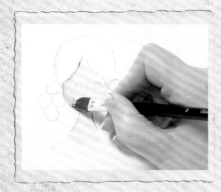

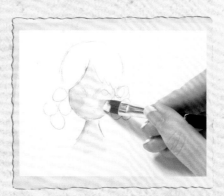

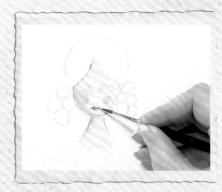

7. Begin adding some shadow of light brown down one side of the cheek to start to make the face look 3-dimensional. Add shadow down one side of the neck.

8. Add some pink color to the cheeks—keep it fairly light and blend in the edges for a more natural look. To make the paint more transparent, mix with gel medium.

9. Using a very fine paintbrush, draw the lips in red. You could also use a fine-tipped alcohol-based marker for this.

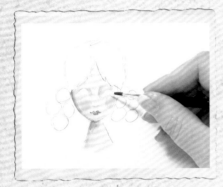

10. Fill in the area of the eyes with white paint. Darken the shadows along the cheek and down the neck.

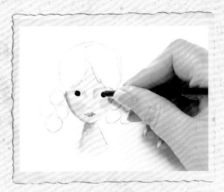

11. Dip the back of the paintbrush into black paint and add the pupils to the eyes.

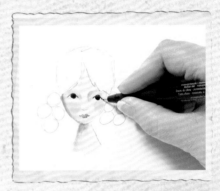

12. Use a black fine-line marker to draw in the upper eyelid.

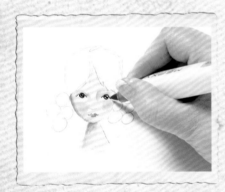

13. Add some colored shadow above the eye, using a light green marker or paint. Next, add white highlights to the pupil.

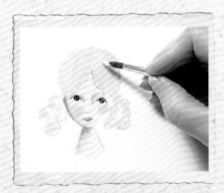

14. Paint the light base coat over the entire area of the hair. You can make the hair any color you choose, but use a lighter shade for this first layer.

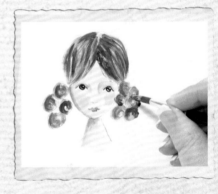

15. Next, add a darker color over the top, keeping the brush strokes separate and feathery to indicate strands of hair.

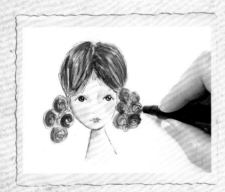

16. Add finishing touches and more detail where necessary, using the black fine-line marker.

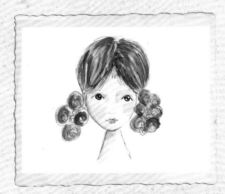

17. The finished face. If you don't want to paint your own version, you could color copy this picture to the size you need.

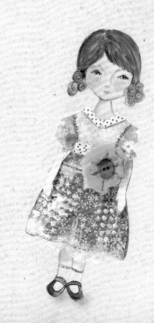

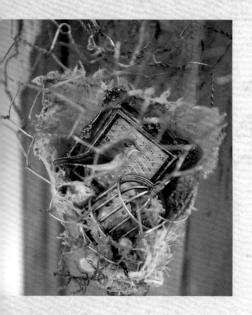

DECOUPAGE

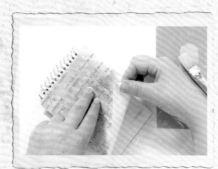

Apply the découpage medium to both surfaces—the back of the image and the front of the item to be découpaged. Layer the image on top of the item. Apply a top coat of découpage medium to smooth away any air bubbles. Leave to dry.

MAKING TEXTURE

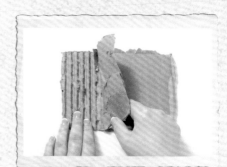

Tear away some of the surface layer of packing cardboard to reveal the corrugated texture on the inside. You can use this to stamp with, or as a material in its own right. Try highlighting the edges with paint or ink.

DISTRESSING

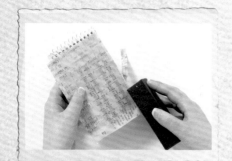

Imitating wear and tear Use a sanding block lightly to take away some of the paint and expose the surface to create a worn, distressed effect.

Aging edges If the piece has brash cut edges, color along the cut edge with a stamp pad or a marker pen to add shading for a vintage effect.

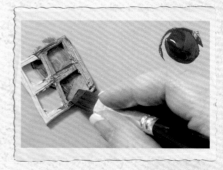

Aging with texture and color Add texture and then emphasize it with color across the high points or worked into the cracks.

USING BOTTLE CAPS

1. Peel a resin sticker (page pebble) off the backing sheet and stick down over the area of the photograph you want to use. Cut around the sticker.

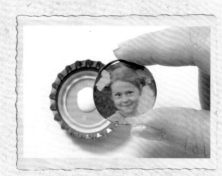

2. Glue the photo into the base of the bottle cap. Bottle caps are ideal as instant frames for photographs or small items.

CUTTING WIRE MESH

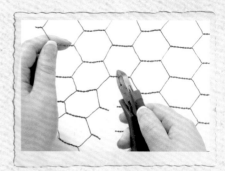

Cut chicken wire mesh roughly to size and shape by snipping through the twisted wire join between the open holes.

STITCHING ON WIRE SHAPES

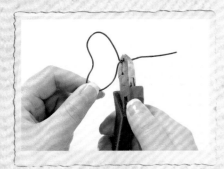

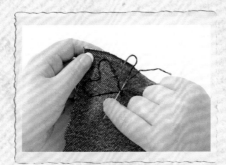

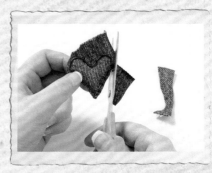

1. Shape the wire by hand roughly into the desired shape—it doesn't have to be perfect; a homemade, rustic look is good. Twist the ends of the wire together to hold the shape.

2. Place the wire shape on a small piece of fabric and stitch around it, using contrast embroidery floss and overcast stitch. Keep stitches close together so the wire shape is secure.

3. Cut around the wire shape, leaving a small border of fabric—be careful not to cut through the stitching. Try experimenting with different embroidery stitches.

USING MODELING PASTE

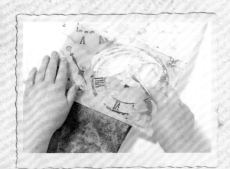

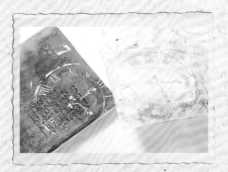

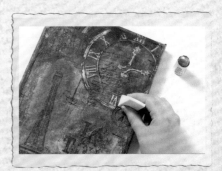

1. Lay the stencil where desired and molding paste over the top, using a popsicle stick.

2. Lift off the stencil, being careful not to smudge the raised image, and allow the image to dry completely.

3. If required, add color highlights with a cosmetic sponge to the high points of the raised motif. If the molding paste has been placed over an area of color wash, the paste will soak up some of the color as it dries, giving it a nice effect.

MAKING MOLDED MOTIFS

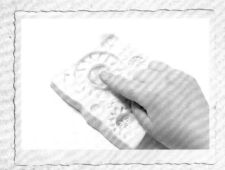

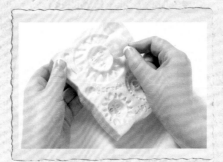

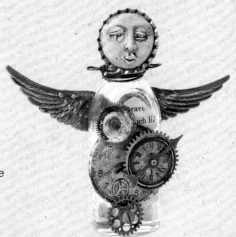

1. Mix up thermoplastic pellets, polymer clay, or fibercast plaster according to the directions. Roll into a ball by hand and press into the mold from the center outward.

2. Allow the mold medium to cool or dry completely before trying to remove the item from the mold. You can then paint the molded motif or add any finishing touches such as distressing.

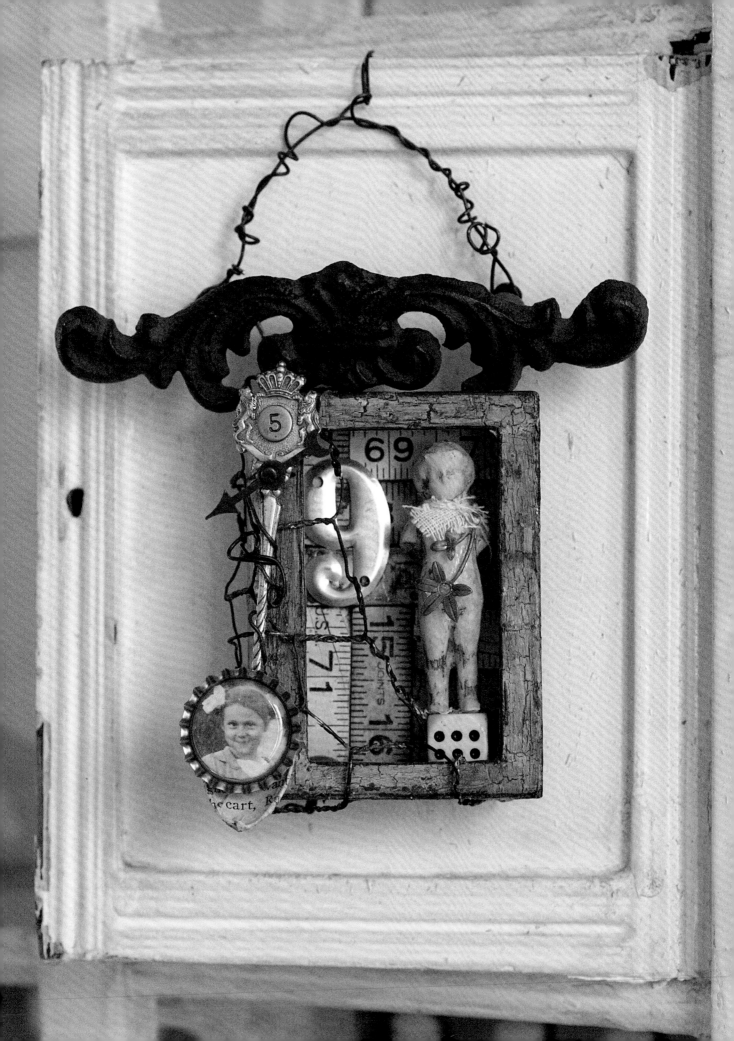

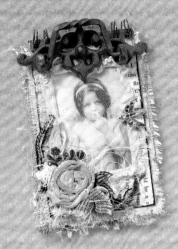

1

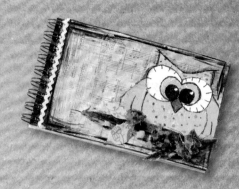

UpCycle & Recycle

The projects in this chapter are really easy, just to start you off. Most of them are based on the technique of collage, which is very simple but can be used to build up quite complex-looking effects. Many projects also use found items, which will begin to teach you how to look at ordinary things around you with new eyes.

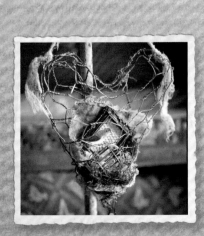

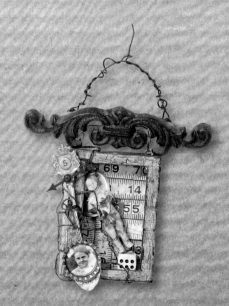

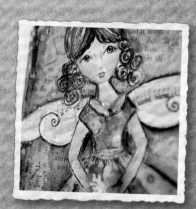

MOmENtS in TiME

This project is inspired by the idea of time passing; we should remember the good times with affection and know that even the bad times are only fleeting in the scheme of things. Use the bottle to store tiny mementos that remind you of a specific time, or keep adding items as a record of a period in your life.

materials

1oz (25g) thermoplastic pellets or sticks

Electric melting pan or heat gun

Face mold of choice

Gesso

Paintbrush

Acrylic paint in flesh tone, raw umber

1 bottle cap

Craft adhesive

Filigree ring finding

20-gauge/0.8mm copper wire, tarnished

Round-nose pliers

Arrow spinner

Tiny screw

Page from book

Decoupage medium

Miniature bottle with flat side and screw top

Clock face clip art

Old watch parts

Miscellaneous gears

2 tiny nuts

2 wings

Silicone-based adhesive

Old buttons or beads

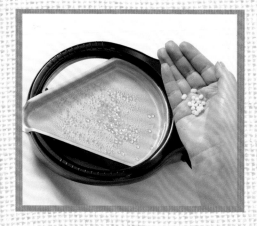

1. Heat the thermoplastic pellets until they soften and begin to melt together. It's best to do this in an electric melting pan, but if the thermoplastic is in stick form you can also use a heat gun.

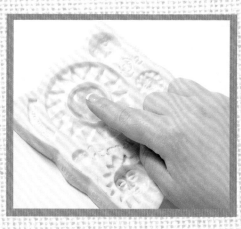

2. Allow the softened plastic to cool slightly and then shape into a ball by rolling it in your hands. Press the ball into the mold, working from the center of the shape outward.

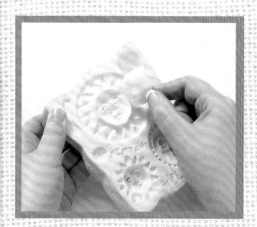

3. Allow the plastic to cool completely before trying to remove the item from the mold. Paint the molded face with gesso, allow to dry, and then apply flesh tone paint to the face. Allow to dry.

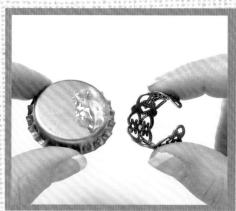

4. Distress the face with a little raw umber (see page 30) to give an antique finish. Glue the face inside the bottle cap and then glue the bottle cap to the ring finding. Allow the adhesive to dry.

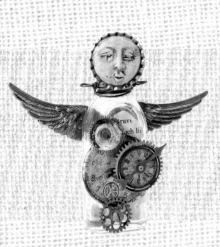

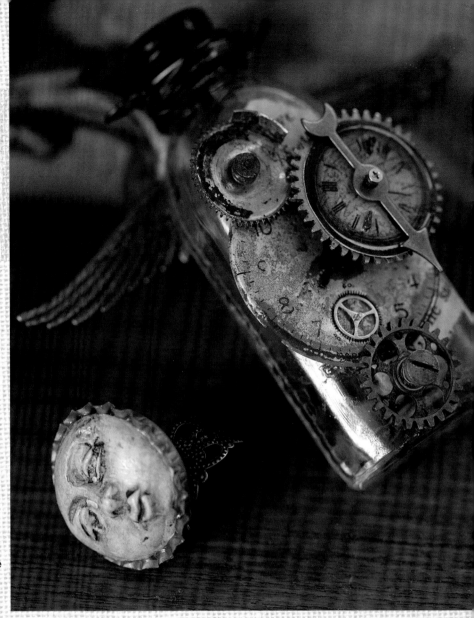

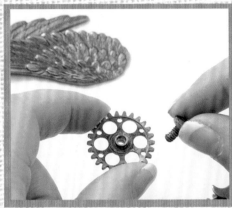

5. Wrap wire around the neckline of the bottle, making a loop on either side. Arrange the arrow spinner over one of the gears and screw together with a miniature screw—or you could glue these together. Decoupage a scrap of book page to the front of the bottle (see page 30).

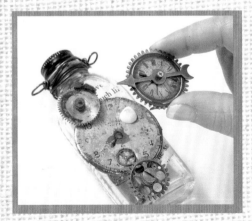

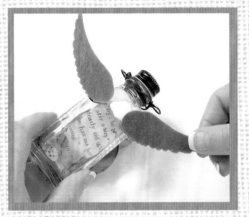

6. Decoupage the clock face to the front of the bottle in the center, over the top of the decoupage paper. Glue a suitable selection of watch parts, gears, and nuts onto the front face of the bottle, both around and on top of the clock face.

7. Attach the two wings to the back of the bottle using dabs of silicone-based adhesive. Allow to dry thoroughly. Put buttons or beads inside the bottle if desired, then screw on the top. Snap the face/ring assembly around the screw top.

HElPFuL HiNT

If you don't want to use thermal plastic to make the face, you could substitute polymer clay or even papier mâché.

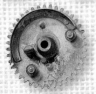

L.o.v.e

I "LOVE" this project simply because there are no rules and it forces me to think creatively. Gather as much old junk—keys, broken jewelry, zippers, clothing remnants, chains, bottle caps; you name it—and have fun with this project! Feel free to use your own items or create one like mine.

materials

- Clothespins (as used for clothespin dolls)
- Large rubber stamp
- Inkpad
- Alcohol-based inks
- Paintbrush
- Craft adhesive
- Bottle caps
- Silver glitter glue pen
- Rhinestones
- Packing cardboard
- Scissors
- White acrylic paint
- License plate letter
- Metal file
- Large flower
- Distressing ink
- Zipper
- Short length of jeweled chain
- Needle and embroidery floss (thread)
- Jean pocket
- 19-gauge/0.9mm annealed steel wire
- Wire cutters
- Selection of embellishments of your choice

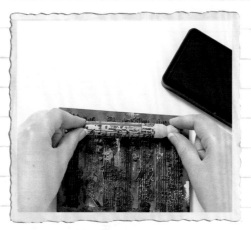

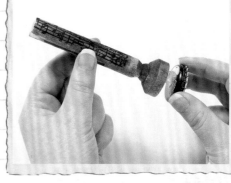

1. Ink a large rubber stamp and roll the clothespin over it to pick up the image. Colorize the design with the alcohol-based inks.

2. Use a dab of adhesive to glue a bottle cap to the bottom of each clothespin to create a firm base for the letter pedestal to stand on.

3. Put a small dab of glitter glue in each of the indents of the bottle cap. Glue on rhinestones and as many other embellishments as desired. Cut lengths of wire to wire-wrap the pedestal decoratively, as described on page 50; alternatively, you could wire-wrap the entire piece as a final step—see the photograph above right for some ideas.

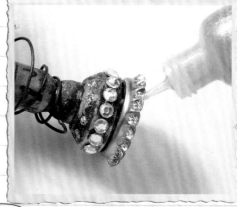

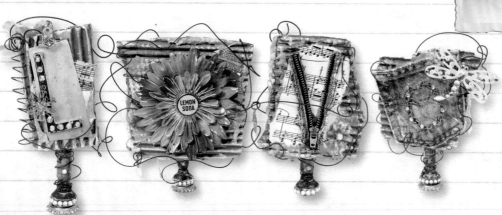

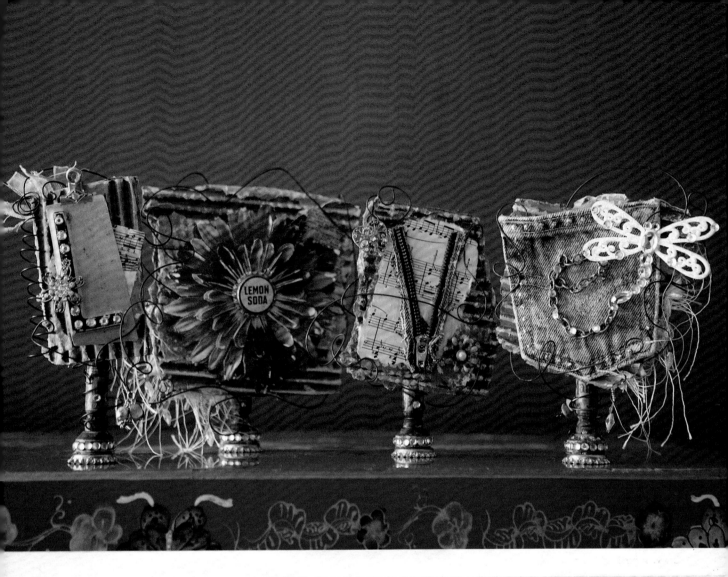

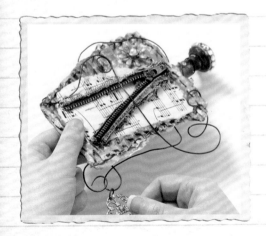

4. Tear cardboard into squares and rectangles to make a backing for your letter and expose the texture (see page 30). Lightly brush white paint over random areas to highlight the texture. Glue the letter backing onto the pedestal. Add a suitable letter shape—see the box, right, for some ideas.

HE1PFuL HiNTs

Be creative when choosing items to make your letters. Ideas include:

Cut the "L" from an old license plate and file the edges smooth.

To create an "O" distress a large flower and glue a bottle cap to the center.

Cut a zipper from a pair of child's jeans and stick onto the backing in a "V" shape.

Stitch a length of chain into the shape of an "e" on a jean pocket.

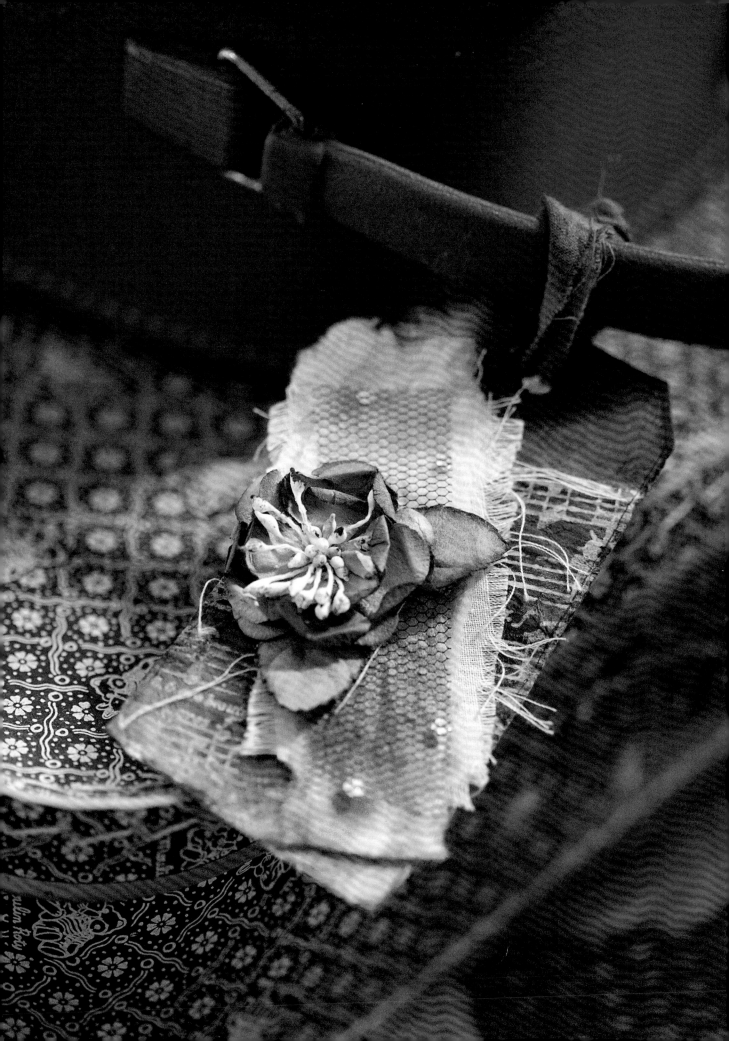

FLoRAl tAgs

I often create tags when I want to experiment with a technique or create something quickly. Source tags at the office supply store as an inexpensive surface for your artistic playtime.

materials

Office shipping tags

Color wash in pink, green, ocher

Spritz bottle

Stamp pad in contrast color to wash

Paintbrush

Page from an old book

Baby wipes

Small square of tulle

Craft adhesive

Needle and thread

Strip of dyed muslin (calico)

Old buttons

Miscellaneous findings, old charms, beads, keys

HElPFuL HiNTs

You can add additional old beads, buttons, keys or charms to the tag as desired to get the effect you want.

You could also use up left-over flowers from another project or purchased flowers to decorate the tag—they are designed for experimentation, so try out any idea that you please.

1. Wet the tag and crumple it up to give it a worn, distressed look. Flatten the crumpled tag out again and leave it to dry thoroughly before adding any further decoration. Spray on the three different color washes. Rub over lightly with the stamp pad to highlight some areas and to add an aged effect.

2. Dip a paintbrush in clean water and soften the color over the tag. Tear pieces of book page into rough leaf shapes— don't worry about trying to make them perfect. Spray the baby wipes with color to coordinate or contrast with the tag colors. Tear the wipes into random circles about 1⅛in (4cm) in diameter.

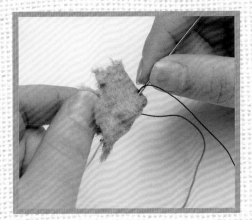

3. Pinch the center of each circle and then fold the sides of the baby wipe up into a simple flower shape. Make a couple of stitches through the base of each flower just to hold the shape in place. Collage together two or more of the baby-wipe flowers and secure with a dab of adhesive.

4. Add the flowers to the square of tulle and the paper leaves to make a pleasing arrangement. Attach the flower collage to the front of the tag with a dab of adhesive. Fold a strip of dyed muslin (calico) in half, thread the loop through the hole in the tag, and then thread the ends through the loop.

DArK HeARt CaNVaS

I created this during a dark time in my life, but the process of making it was very therapeutic. The heart is a universal symbol of love and friendship, but when we are unhappy we might talk about being heartbroken so this project could be suitable for many different occasions, both happy and sad...

materials

Sheets of old music or book pages

Decoupage medium

Paintbrush

12 x 12in (30 x 30cm) canvas

Acrylic paint in colors of choice

Color wash colors of choice

Objects to create texture

Fine-line black permanent marker

Colorful page from a magazine

Bamboo skewers

Craft adhesive

6 x 8in (15 x 20cm) cardboard

Small piece of aluminum foil

Metal heart charm

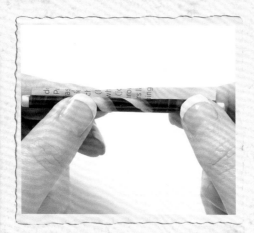

1. Create your chosen background (see page 26) on the canvas and add a heart outline, using the photograph opposite as a guide. Tear strips from a magazine page and roll around bamboo skewers to create tubes of different sizes and lengths. Slide the tubes off the skewers.

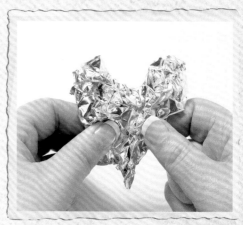

2. Tear the upper paper layer from a small rectangular scrap of the cardboard (see page 30). Scrumple up the piece of aluminum foil and shape between your fingers to make a small, fairly flat but still three-dimensional heart. Add a little color to the heart using acrylic paint.

3. Arrange the paper tubes in a row to the top right area of the background canvas. Don't align the tubes perfectly, they should look random. Add the scrap of cardboard on the top and add the aluminum heart on top of this.

4. Cut the medium-size heart from a piece of cardboard and color as the background. Outline with black pen. Make small stacks of cardboard scraps at the bottom left of the canvas and mount the heart on top to stand in relief. Add the metal heart charm to the right-hand side of this heart.

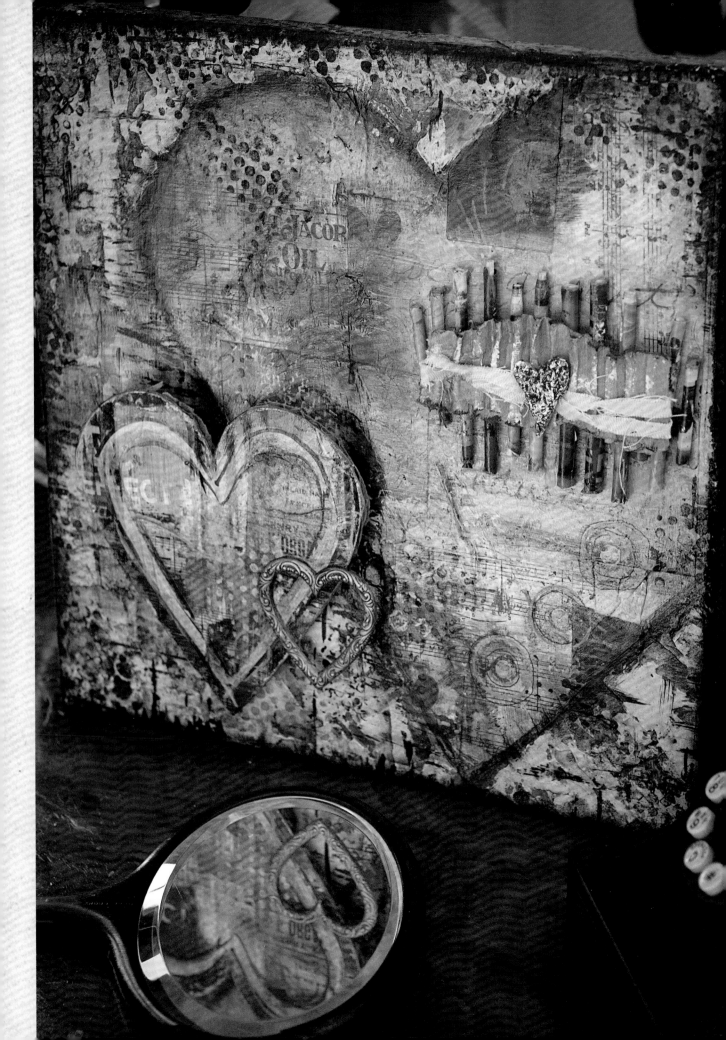

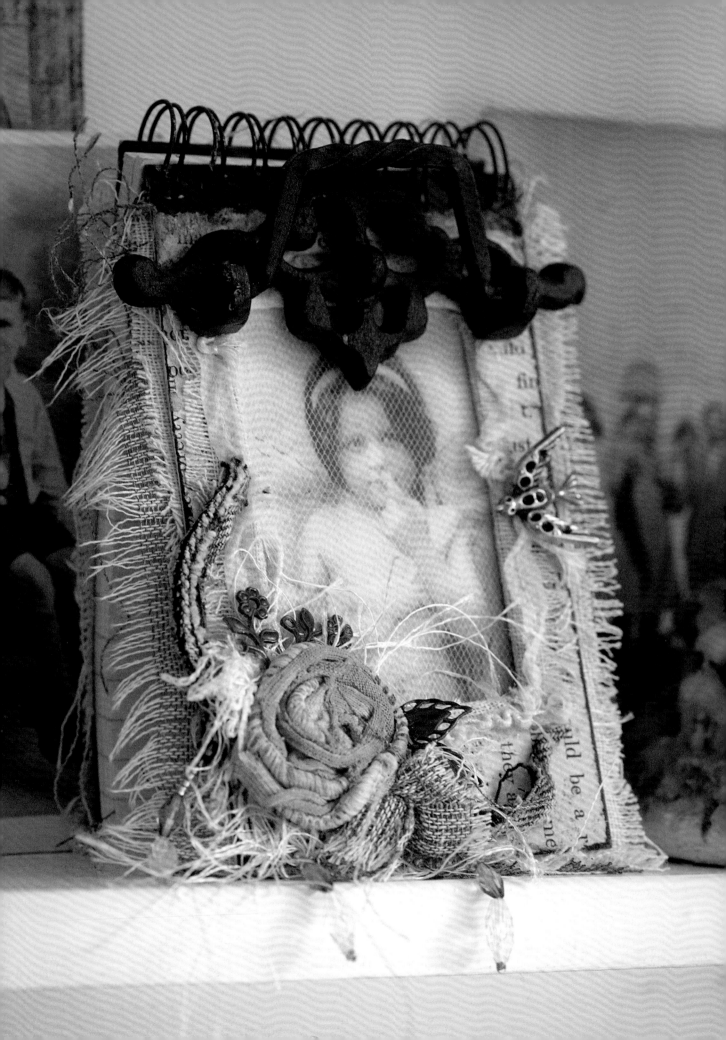

InnOCenCe OF a CHilD

Spiral-bound notebooks are inexpensive and easily available, but usually not very attractive. Mixed media techniques are ideal to add some pizzazz to your own notebook—here's a project to give you some ideas. The draw pull not only hides the ugly metal spiral at the top, but also instantly adds a touch of class.

materials

- Small spiral notebook
- Decoupage medium
- Page from an old book
- Inkpad in brown
- Craft knife
- Sanding block
- Scissors
- Scraps of old white T-shirt seams
- Spray color wash in ocher
- Needle and thread
- Beaded trim
- Fiber trim
- Fabric scraps
- Tan ribbon
- Bird charm or embellishments of choice
- Metal drawer pull
- Small piece of tulle
- Photograph of choice
- Silicone-based adhesive
- Muslin (calico)

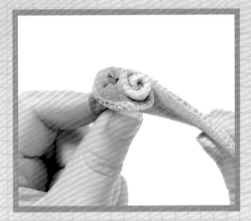

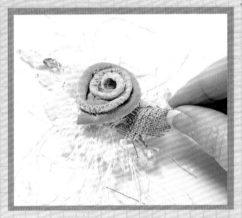

1. Decoupage the paper to the covers of the notebook and decorate with distressing ink and fabric scraps. Cut a rectangle out of the front cover to create a frame. Spray a strip of T-shirt seam with ocher and allow to dry. Roll up the strip into a coil to create a vintage-look rose and stitch to hold in place.

2. Arrange scraps of beaded trim, fiber, and fabric scraps behind the rose to create a pleasing and roughly triangular shape arrangement to go onto the lower left corner of the notebook. Glue on additional embellishments of choice around the frame.

3. Add the metal drawer pull across the top of the notebook to conceal the spiral. Glue tulle to the back of the frame opening in the front cover and a photograph onto the tulle. Cover the inside back with muslin (calico) and fray the edges decoratively.

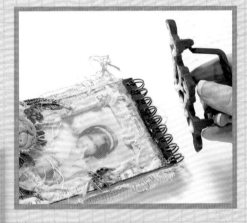

HElPFuL HiNTs

Choose fabrics that tear and fray easily for this project to add texture and maximize visual interest.

While creating the notebook cover, wrap the inside papers with wax paper to protect them from the adhesive and keep the pages clean—you can tape the wax paper into place. Alternatively, slip the main part of the book into a small plastic bag and tape in place.

STaMPeD owl JoURnAL

I like to have a small notebook in my purse to draw in or to make notes of ideas that occur to me when I am out. Here we create a simple and cheerful cover design using stamping—make a motif for your notebook that is truly personal.

materials

Templates on page 124

Craft foam

Scissors

Craft adhesive

Small notebook

Decorative paper

Decoupage medium

Paintbrush

Acrylic paint in green, turquoise, white, blue, black, white, orange, brown, red

Fine-line permanent marker in black

Scrap of cardboard

Scrap of muslin (calico)

Fabric scraps in green and red

Brown distressing ink

Sanding block

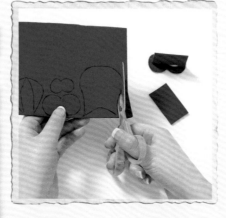

1. Transfer all the owl template shapes on page 124 onto a sheet of craft foam. Cut out the shapes with scissors and cut some extra short strips of foam to use as handles. Glue the handle strips edge-on to the back of the stamp.

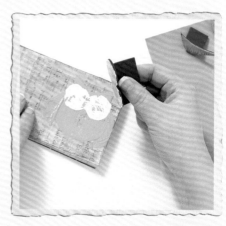

2. Decoupage decorative paper onto the front of the journal (see page 30). Allow to dry. Apply green paint to the owl body stamp and stamp at one end of the cover. Stamp the wing in turquoise, the eyes in white, and the iris in blue. Color the pupil black with a marker or paint and add a white highlight. Allow the owl to dry.

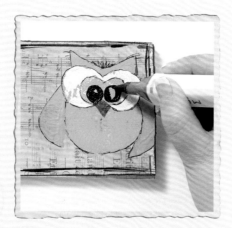

3. Outline the pieces with a fine-line marker and add any additional details such as polka dots or stripes to the owl body. Paint in the orange beak. Outline around the cover with red and brown paint.

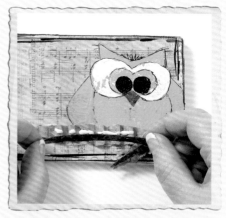

4. Tear a piece of cardboard to a branch shape and glue onto the front. Paint a strip of muslin (calico) brown, cut into a branch shape and glue over the cardboard. Cut leaves from green fabric and glue to the branch.

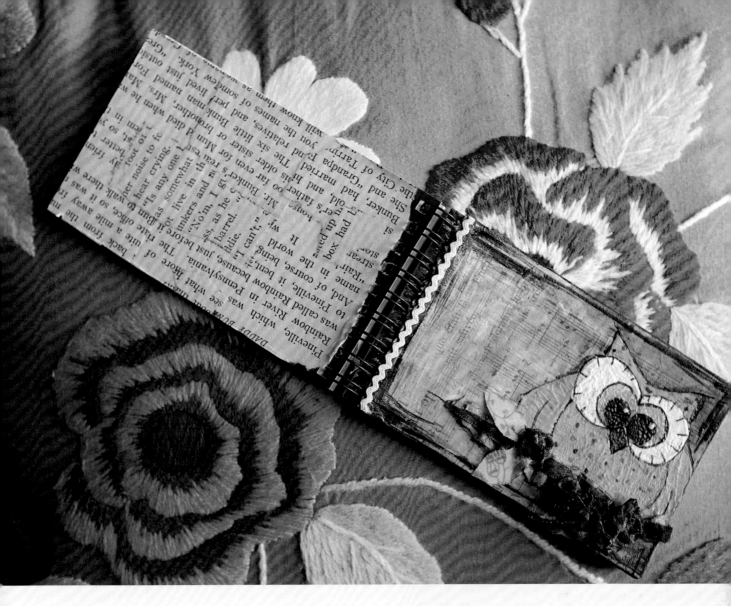

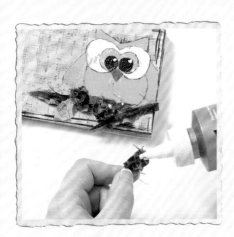

5. Cut three small circles of red fabric and bunch together in the center to make rough flowers. Glue each flower to the branch. Distress the edges of the cover (see page 30).

HElPFuL HiNT

This technique can be adapted for any size of notebook—just enlarge the template to a suitable size for the cover.

DaNCiNg GIrL CaNVaS

Making original art is very easy—you don't need to be a great artist or even be able to draw well. On this project the canvas is layered with images, using various techniques, resulting in a professional-looking finished result. You could use a photograph of a real person as a base for the doll.

materials

Decoupage medium

Sheet of old music

8 x 10in (20 x 25cm) canvas

Odd scraps of old printed paper

Craft adhesive

Distressing ink

Templates on page 122

Acrylic paints in flesh color, turquoise, white, red, lime green

Paintbrush

Stencil

Molding paste

Popsicle stick

Paper flowers and leaves

Jewel sticker motif

Butterfly sticker or rub-on motif

Bubble wrap

Selection of beads

Black fine-line permanent marker

Charcoal pencil

1. Decoupage the sheet of music onto the canvas (see page 30). Add printed paper scraps. Apply distressing ink in coordinating colors and stamp on any texture desired (see page 26). Use the template on page 122 to cut out the pieces for the doll and color in the arms and face with flesh color acrylic paint (see page 28). Build up the skirt by collaging pieces on top of one another.

2. Arrange all the doll pieces together to create the doll and decoupage them positioned to one side of the canvas. Place the stencil over a suitable area of blank canvas on the opposite side to the doll. You can use just part of the stencil or the whole motif. Smooth some molding paste over the stencil with a popsicle stick (see page 31).

3. Glue the paper flowers and leaves where desired to fill in any blank areas near the bottom of the canvas. Remove parts of the jeweled sticker from the carrier sheet and press them firmly onto the canvas.

4. Apply the butterfly sticker or rub-on motif in the desired position. Paint bubble wrap with acrylic paint and stamp on the canvas over the designs to create additional layers of texture and dimension (see page 26).

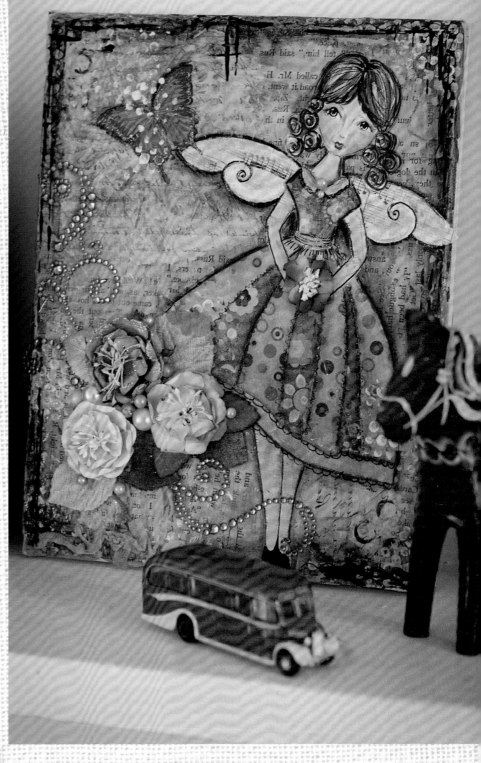

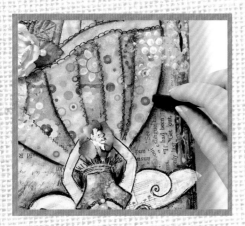

5. Outline the edge of the skirt and one side of the doll, using a charcoal pencil. Using your fingertip, blend the charcoal to form a shadow around the doll. Finish by adding any additional texture or squiggly lines with the fine-line permanent marker.

HElPFuL HiNT

If you don't want to draw and paint a face for your doll, you can copy the finished face on page 29 to a suitable size.

AntIQuiTiES bOX

When I was five, my Auntie Jeanette had a dollhouse custom made for herself and I imagined what it would be like to live in a world so tiny. This box is reminiscent of that special time with my Auntie and her dollhouse. It's the perfect size to showcase those memories that are precious to me. What objects would you include to remind you of your childhood?

materials

- Small book-shaped box
- Paint in tomato red, yellow ocher, burnt umber
- Paintbrush
- Crackle glaze
- Small china doll or similar
- Dice
- Craft adhesive
- Small scrap of muslin (calico)
- Findings of choice
- Old photograph
- Bottle cap
- Resin sticker (page pebble) to fit bottle cap
- Old spoon
- 19-gauge/0.9mm annealed steel wire
- Wire cutters
- Craft knife
- Sanding block
- Permanent marker
- Old extendable wooden ruler
- Metal number
- Miscellaneous found objects
- Small piece of chicken wire
- 2 screw-in eyelets
- Decorative drawer pull
- Pliers

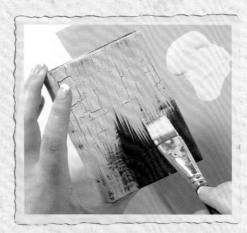

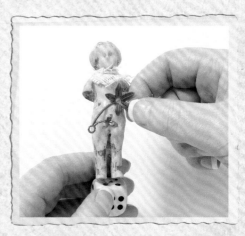

1. Paint the entire box tomato red and allow to dry. Apply a generous coat of crackle over the red paint and let dry. Brush a top coat of ocher paint and allow to dry completely—the crackle effect will appear as it dries.

2. Antique the doll and the dice with a little burnt umber paint if desired. Glue the doll to the dice. Add a small triangle of muslin (calico) as a scarf around the neck of the doll. Glue on a selection of findings to the front of the doll.

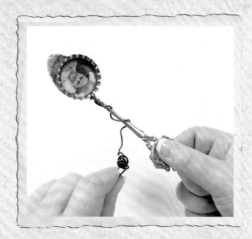

3. Glue the photograph inside the bottle cap and apply a resin sticker over the top. Glue to the base of the spoon. Cut a short length of wire and wrap it decoratively around the top of the spoon. Add any decorative findings of your choice.

HElPFuL HiNTs

The little doll used is commonly called a frozen Charlotte and can be found in flea markets and thrift (charity) stores. Replicas called fractured dolls can be found in your local craft stores.

In step 6, age the chicken wire by painting it with a little burnt umber paint.

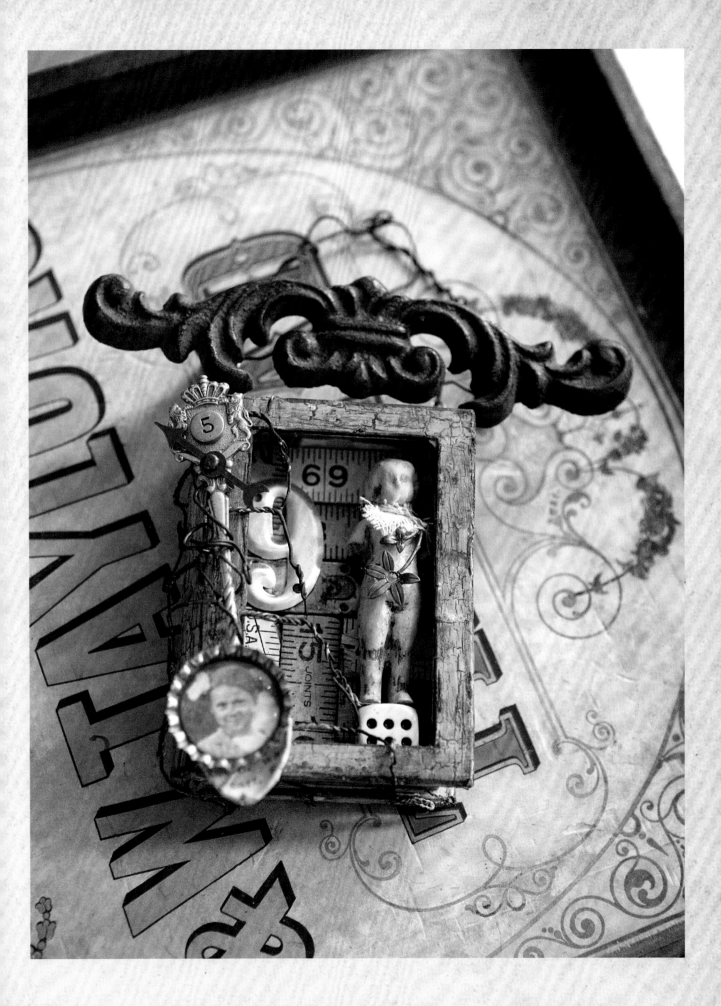

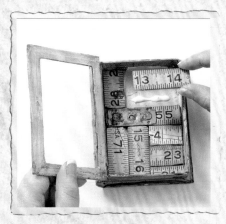

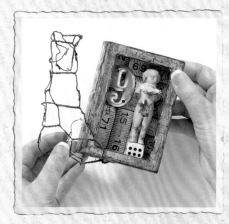

4. Cut a 2 x 3¼in hole (5 x 8-cm) hole in the front cover of the box using a craft knife, to create a framed opening. If there are any rough edges, sand them down. Run a marker around the raw cut edge of the opening to tone down the color so that it blends in with the box.

5. Cut pieces of wooden ruler to different lengths to fit inside the box in an attractive arrangement. Stick the lengths down with dabs of adhesive. Alternatively, you could use a piece of decorative paper to line the inside of the box.

6. Glue the doll to the inside of the box, with the number to one side. You can add as many decorative pieces to this project as you wish, using items that mean something to you personally. Fold a small piece of chicken wire over the bottom corner of the box, pressing to the box shape.

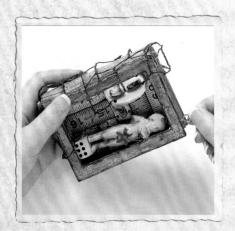

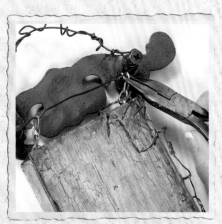

7. Screw in an eyelet on either side of the top of the box near the rear edge. Add a three-link length of chain to each eyelet. Cut a piece of wire about 12in (30cm) long.

8. Wrap one end of wire around one of the pegs on the back of the drawer pull, bend the wire over the top to create a handle, loop it around the opposite peg and then across to the first peg, wrapping to secure. Wrap additional wire around the handle to decorate. Attach the ends of the chain to the wire between the pegs. Attach the spoon on top of the frame at one side using wire. Add any additional embellishments as desired.

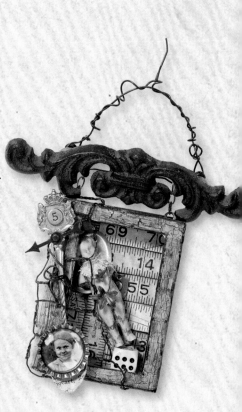

materials

- 12-in (30-cm) strip of 1 ½-in (4-cm) wide open-weave cheesecloth
- Hot tea
- 2 x 4in (5 x 10cm) natural color linen or muslin (calico)
- Green water-based spray dye
- 1 x 8mm pearl bead
- 1 x 10mm pearl bead
- White craft adhesive
- Scissors
- Watch parts—I found one in the shape of a wing
- Black permanent marker
- Page from an old book
- Small piece of fine wire mesh
- Miniature picture frame
- Small bird image
- Short length of beaded trim
- Basic jewelry pliers
- 19-gauge/0.9mm annealed steel wire
- 21-in (52.5-cm) square of chicken wire
- Wire cutters
- Decorative button
- Round-nose pliers
- Birdcage pendant
- Spanish moss

HEaRT oN a WiRE

I especially love the unexpected—when the common meets the uncommon, as in this project. The contrast between the "hardware" chicken wire and the "soft" texture of the textile offers a nice balance of both. The bird motifs inside remind me of a little red bird who would perch outside my window every morning last summer, enchanting me with his cheerful melodies. What a great start to the day and I sure hope he comes back! Challenge yourself in this project to use two materials you feel are in total contrast, whether hard and soft, dark and light, or maybe even big and little. You, too, will find that unexpected balance in your artwork.

1. Tea dye the strip of cheesecloth (see page 27). Spray dye a small piece of linen as described on page 27. Glue the two pearl beads together. While the adhesive is wet, wrap a small piece of cheesecloth around the beads and create a beak shape on one side of the small bead.

2. Glue on the watch part to one side of the larger bead with a dab of adhesive to create a wing. Add a dot in black marker pen on the small bead for the bird's eye. Leave the bird to one side to dry fully.

3. Cut a small piece from the book page and a section of the fine wire mesh to fit the frame. Layer the wire mesh over the printed paper and glue behind the frame. Glue the bird image to one side of the frame front.

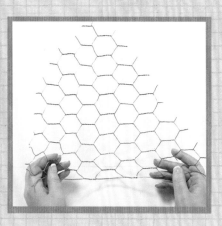

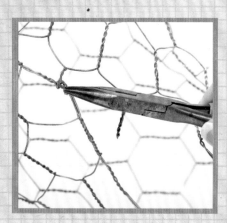

4. Snip a short section of bead dangle from a length of beaded trim. Holding the edge of the trim header tape firmly with a pair of pliers, wrap a length of wire around the top a few times. Cut off the excess wire, leaving a long end.

5. Cut a triangle of chicken wire mesh as described on page 30, with two sides measuring 14½in (36.5cm) and the third side 21in (52.5cm). Shape this triangle into a cone using your hands, and also a pair of pliers if necessary.

6. Using pliers, bend all the wire ends tightly around a suitable length of wire on the opposite side of the cone shape to secure. Trim off any sharp or unnecessary ends using the wire cutters.

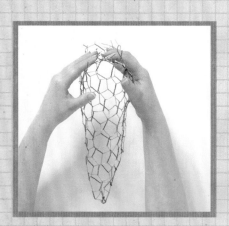

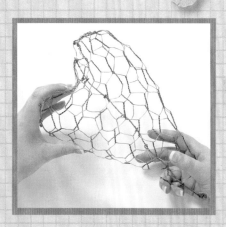

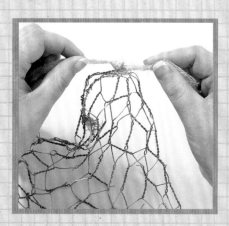

7. Press the top of the cone together, secure the ends, and then trim off any sharp ends as before.

8. Push down into the center of the cone at the top and shape it into a three-dimensional heart.

9. Cut a 10-in (25-cm) length of the dyed cheesecloth and knot the ends at the top of the heart on either side. Stitch a decorative button to the center.

HElPFuL HiNT Use a little caution when shaping, because the chicken wire can cause injury. If you are concerned, wear leather gloves.

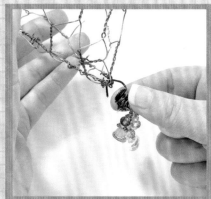

10. Bend the end of the wire at the end of the dangle over into a half loop with round-nose pliers. Hook this onto the base of the heart and then close the loop into a ring to secure. Trim off any excess wire.

11. Decoupage (see page 30) a small image onto the flat back inside the birdcage pendant. Add the bead bird inside the cage and close the back. Snip a small slit in the back of the heart and insert some Spanish moss and any other elements you desire. Wire the slit closed to finish.

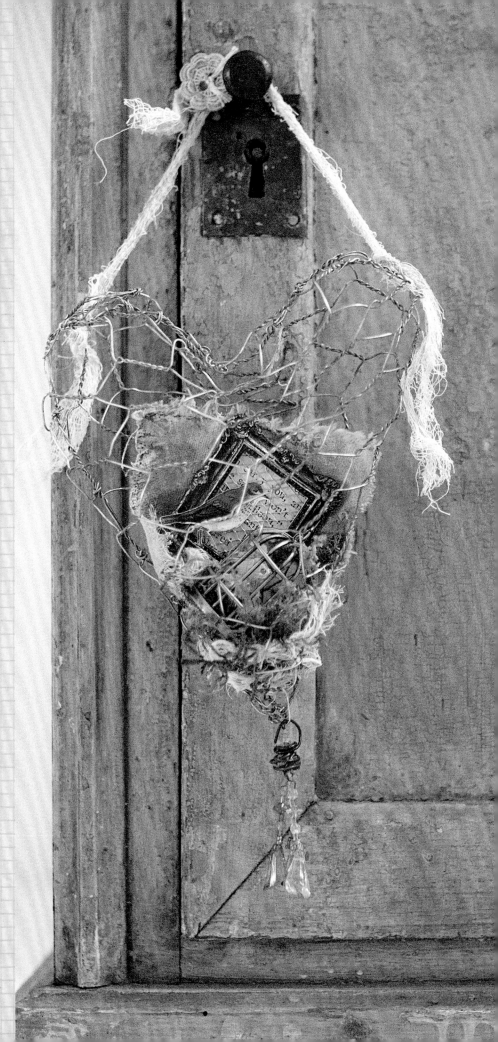

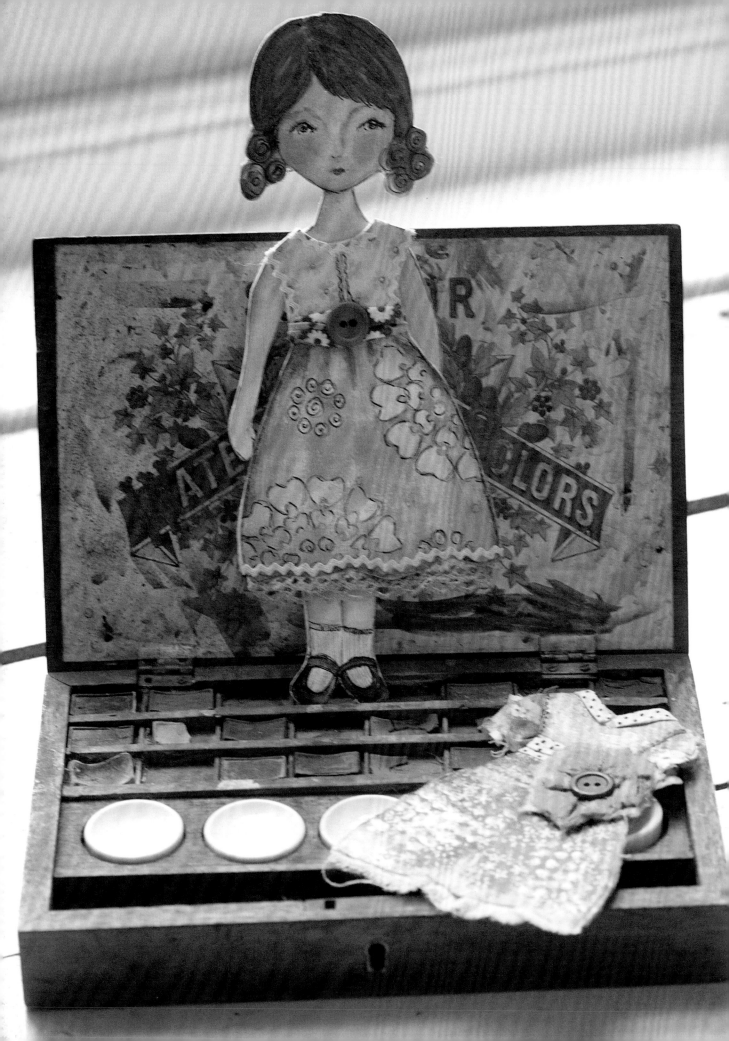

CHAPTER 2

MEMORIES IN THE MAKING

I believe that memories are a valuable gift and that it's important to preserve them; I do just that in my everyday art. Memory art is a way to keep my loved ones close—even if they are no longer with me. And, it cheers me up on a gloomy day. It's equally important to create new memories, so include mementos of both past and present to create a priceless record of the time you spend here.

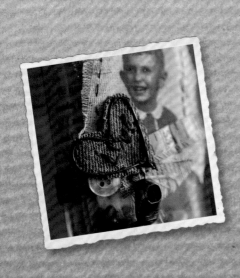

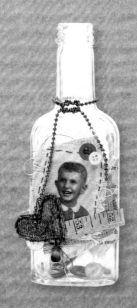

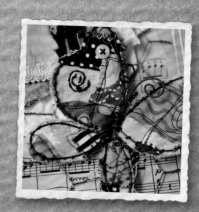

MY hERO

This little bottle is a memento of a very special person in my life—my Dad, Larry. I've used stuff that reminds me of him and what he's told me about his childhood. The simple embroidery is reminiscent of the hours my Grandma Ruth spent mending his clothes—in which he continuously wore holes.

materials

Photograph or image

TAP (image transfer) artist paper

6 x 6in (15 x 15cm) muslin (calico)

Iron

Needle

Scissors

Thread in brown or black

19-gauge/0.9mm annealed steel wire

Round-nose pliers

Small piece of denim

Red embroidery floss (thread)

Shoe charm or charm of choice

Old page from book

Decoupage medium

Paintbrush

Bottle with flat or semi-flat front surface

Measuring tape

Thick white craft adhesive

Old buttons (optional)

Ball chain

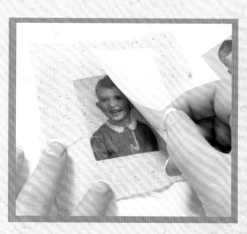

1. Scan your chosen image into the computer and then print it out onto TAP (image transfer) paper using an inkjet printer. Iron the image onto a piece of muslin (calico), using the hottest setting on the iron.

2. Carefully peel off the backing paper to reveal the image on the fabric. Sew a running stitch around the edge of the material to embellish. Fray the edges slightly outside the line of stitching.

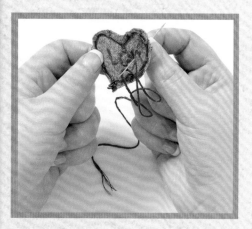

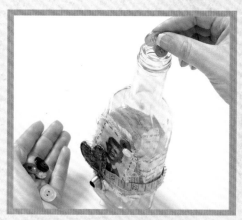

3. Make a wire heart and stitch it to the piece of denim (see page 31). Embroider your desired word in the center of the heart shape, using red floss (thread) and backstitch. Cut out around the wire heart, leaving a small border of fabric. Attach the charm to the bottom of the heart by sewing or with a jump ring.

4. Decoupage the book page to the bottle and add the fabric square and image collage on top, using the photo as a reference. Wrap the measuring tape around the bottle and secure with glue. Glue on the fabric heart. Drop some buttons, charms, and scraps of fabric into the bottle.

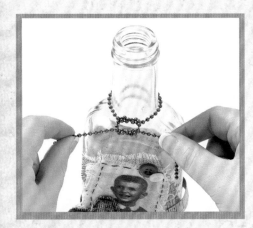

5. Wrap the ball chain a couple of times around the neckline of the bottle and then knot it loosely at the front, leaving the ends dangling down.

HElPFuL HiNTs

If the image you are using has words, letters, or numbers, reverse it in your computer photo-editing program before printing it onto the TAP paper.

Instead of using buttons and beads inside the bottle, consider writing down your favorite memory of this special person for others to treasure for years to come.

Think about your hero. What makes them special and what found objects can you include that will represent them?

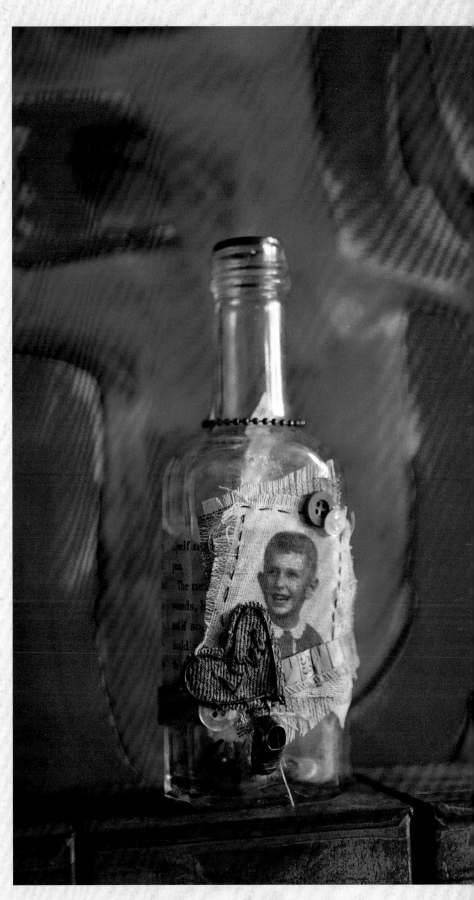

ART JOURNAL:
HOME SWEET hOme

Creating an art journal is a great way to learn artistic expression and simply escape to a far-off place in our creative mind. I gather interesting objects and often have no particular idea in mind, but with this page I thought of my childhood home. I had a flower garden and I used it as inspiration for this artistic representation of a house. Close your eyes and go back in time...

materials

Paper lunch sacks

Scissors

Non-stick craft sheet

Color wash spray dyes for paper

Spritz bottle

Coordinating patterned paper

Templates on page 124

Patterned fabric

Quilt batting (wadding)

Needle and thread

Thick white craft glue

Red felt heart

Fabric flowers

Small mother-of-pearl button

Paintbrush

Pencil with eraser end

Red acrylic paint

Rub-on transfer

Popsicle stick

1. Cut open paper sacks and flatten out on the non-stick sheet. Spray the sacks with the color wash in your chosen colors. Spritz with a little water for a water spot effect.

2. Tear coordinating paper into random shapes and sizes. Using the templates on page 124, cut out pieces of fabric to make up the house and sew to the batting (wadding) with running stitch.

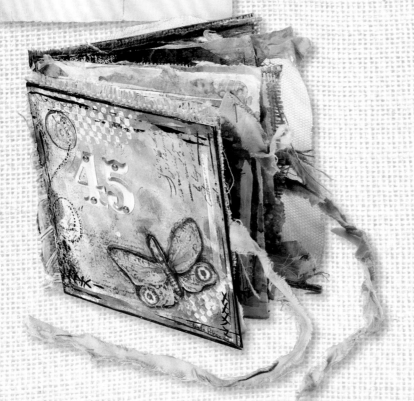

3. Arrange the paper pieces, felt heart, fabric flowers, and button and glue in place. Dip the pencil end into red acrylic paint and dot onto the page to accent.

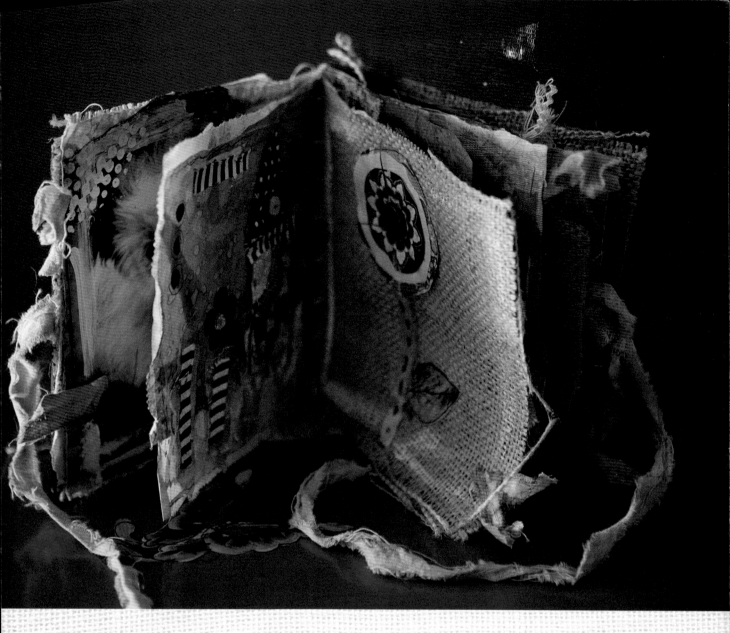

4. Glue the batting (wadding) onto the page, slightly to one side. Use a popsicle stick to apply the rub-on transfer in a clear area of background near the house.

5. Lift a corner of the rub-on transfer carefully to check if it has transferred correctly. If not, carry on rubbing. If it has transferred, carefully peel off the backing sheet to reveal the motif.

HElPFuL HiNT

Use fabrics, buttons, and other embelllishments recycled from old worn-out clothes, quilts, or blankets to give this page a more personal touch.

ARt JOurNaL: mAkinG THe BOOk

Sometimes my mind gets cluttered with ideas and things to do and I find this is the perfect time to create an art journal to free my mind. Don't over-think this project and don't spend too much time contemplating the design elements. Keep it free form; it's very forgiving and will turn out beautiful in the end! Perfection is not required or desired for this project and don't be afraid to write anything you are feeling—good or bad.

materials

Craft knife

12 x 6in (30 x 15cm) chipboard (dense cardboard)

Acrylic paint

Color wash (I used plum, navy, blue, ocher)

Tattered Angels pearl spray (I used red)

Textures such as plastic doilies, bubble wrap

Non-stick craft sheet

Clip art

Rub-on transfers

Stamps

Old credit card

Dyed strips of torn fabric

Craft adhesive

6 x 6-in (15 x 15cm) pieces of paper cut from lunch sacks

Pieces of fabric, burlap, and tulle slightly larger than the pages

Hole punch

Raffia or leather cording

Heavy-duty needle with large eye

Embellishments of choice

1. Cut 6-in (15-cm) squares of chipboard (dense cardboard). Create your desired background for the front cover (see page 26) using paint, textures, and rub-on transfers. Glue the end of a strip of torn fabric to the back center of each piece along one edge to tie the journal closed when finished.

2. For the inside covers, create your chosen background (see page 26) on two pieces of lunch sack paper. Glue a square of the prepared paper onto burlap that is slightly larger than the cover, then glue this onto the inside of the front cover concealing the strip of fabric. Repeat this for the back cover.

3. Make your chosen pages in the fabric, burlap, and tulle (see page 58)—you can leave some pages blank to add more material later. Beginning with burlap, begin layering paper, fabrics, tags, and anything you wish together until the desired number of pages have been reached. Finish with burlap on top. Place the front and back covers on the top and bottom of this stack. Use the photograph as an example.

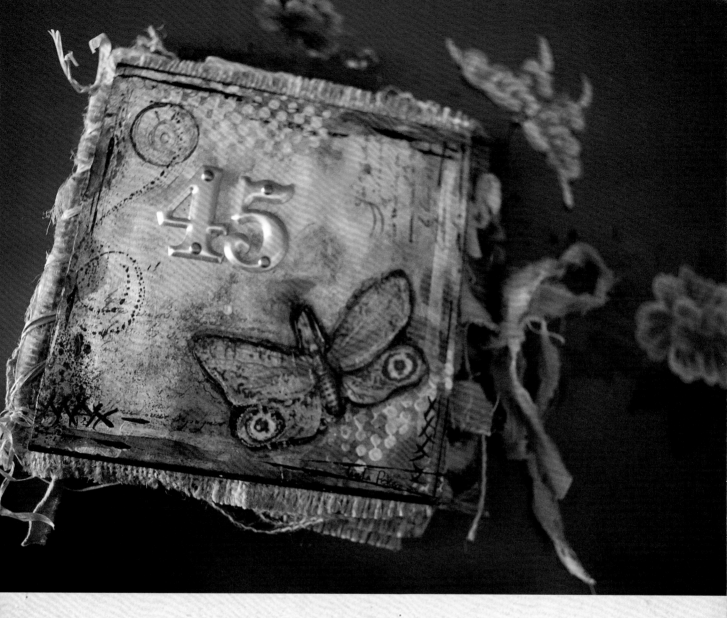

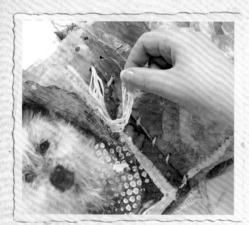

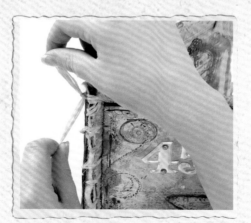

4. Mark the hole placement every ½in (1cm) along the inner edge of each page and the back edge of each cover and punch the holes. Stitch through all the layers using a length of raffia or leather cording and using an overcast stitch to bind everything together securely.

5. Knot the ends of the raffia or cording together to secure and trim back the ends near the knot. Add any additional embellishments such as trims, bits of torn fabric, and numbers to decorate the cover. Allow all the adhesive to dry completely. Now your journal is ready for your words and doodles!

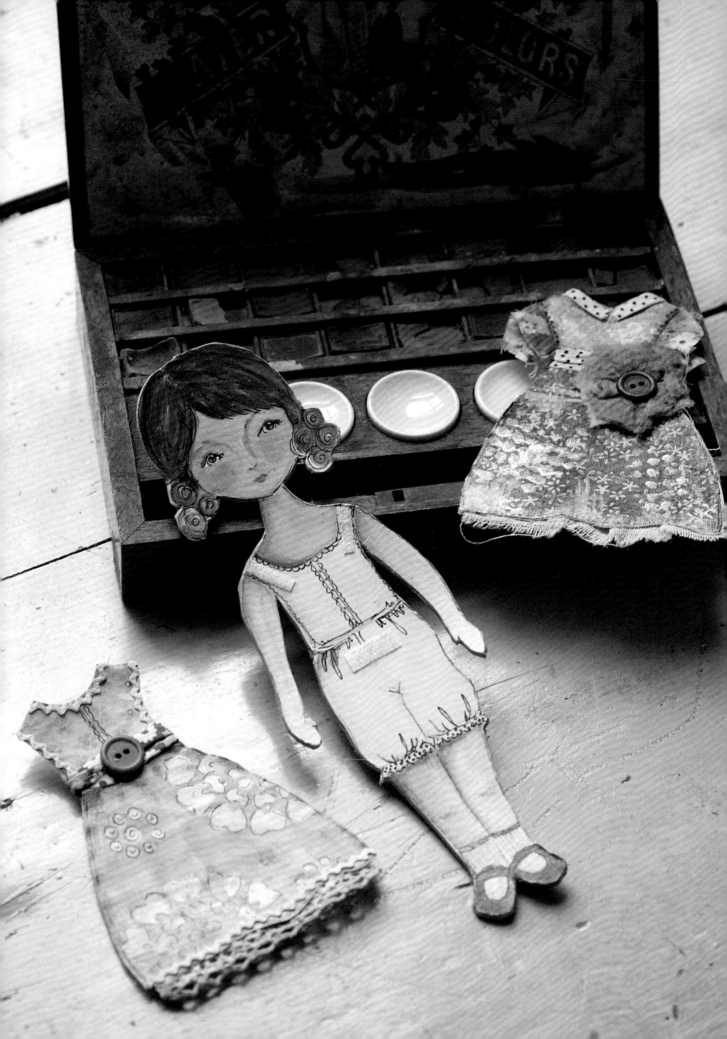

LIttLe mIsS MoLLY PApeR DoLLs

As you can see by now, I use personal memories as an inspiration to create art. My Aunt Marlene, who we affectionately call Aunt Molly, has always loved dolls and paper dolls. They were often a gift to me that would keep me busy for hours. While I used chipboard (dense cardboard) as the basis for this doll, cereal boxes are also a good choice and a great way to recycle and upcycle.

materials

Templates on page 123

Large piece of mixed media/heavy paper

White paper

Acrylic paint in flesh color, tan, burnt umber, white, blue, pink

Paintbrush

Black fine-line permanent marker

Alcohol-based marker in green, blue (color of eyes)

Decoupage medium

Chipboard (dense cardboard) or cereal box

Craft knife

Small square of hook-and-loop tape (Velcro)

Scissors

Decorative fabrics

White felt

Craft glue

Miscellaneous findings such as charms, buttons, beads

Rick-rack and lace trimmings

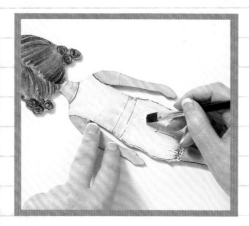

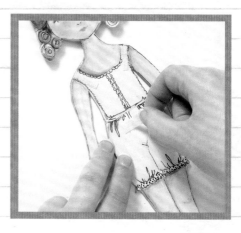

1. Trace the doll front template on page 123 onto mixed media/heavy paper, then reverse the outline to cut the back of the doll. Copy the doll clothes templates onto white paper. Paint the front and back of the doll using the photograph on page 64 as a guide. If you don't want to paint your own doll, photocopy the doll front and back on page 64 in color.

2. Decoupage the front of the finished doll onto the chipboard (dense cardboard) and cut out. Add the back of the doll on the reverse. Outline edges and add any details with a fine-tipped marker. Cut small rectangles of the hook side of the hook-and-loop tape and stick to the front of doll on each shoulder and at the waist.

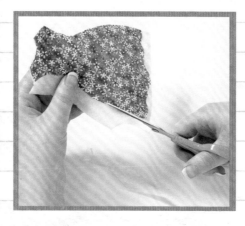

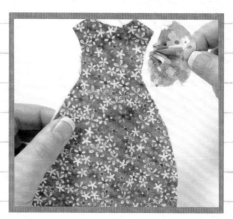

3. Use the clothes templates to cut out pieces of fabric—create variations by cutting out alternative bodices and use different fabrics and trims. Glue the pieces onto white felt and leave to dry.

4. Trim off any excess felt around the shape of the dress. Cut out some extra fabric for the sleeve shape and gather it at one end. Glue to the armhole of the dress to make a puffed sleeve.

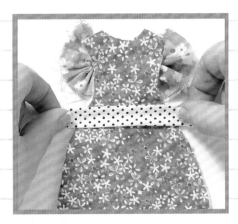

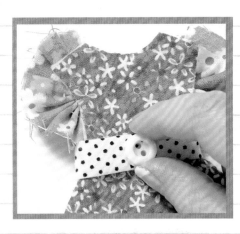

5. Cut out the belt in contrast fabric. Fold the edges of the fabric under along the length of the strip and then glue the belt in place on the dress. Tuck the ends under and stick in place.

6. Add additional embellishments as desired such as stamped designs, tiny buttons or beads, braid, or lace to the dress. Press the dress onto the doll—the felt backing will cling to the hook tape squares added to the doll in step 2.

HElPFuL HiNTs

What can you add to this doll, that reflects something personal to you? Maybe it's a few beads around her neck that reminds you of your mother's necklace, or maybe your grandmother had a love of birds so you could use a bird motif—just let your mind wander, then create…

When painting the doll and drawing in details of the face and hair, allow yourself some freedom of expression.

You can use a heat tool to speed up the drying process between steps.

Vary the clothing by using different combinations of decorative papers and fabrics or create paper and fabrics of your own.

Create multiple versions of the paper dolls with different flesh colors and hairstyles— you could use a real person as inspiration.

Once you create your paper doll, scan it into your computer. You can create larger or smaller versions, print them out and then decoupage them directly to chipboard (dense cardboard). Dress and have fun!

If you make your paper doll a standard doll size, you can add some ready-made doll accessories—such as bags— to your doll.

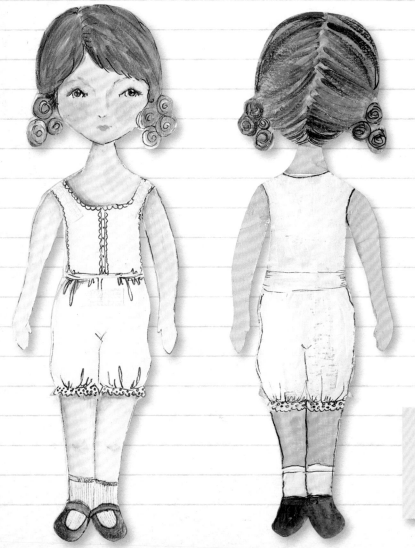

Use these front and back views as a guide to paint your doll—or simply color copy them and mount onto the chipboard.

cRaZY mIxEd-Up LUGgaGe TAg

Have you gone through the baggage claim only to discover that your luggage looks like everyone else's? Yes, I could simply purchase a luggage tag—but creating your own is a sure way to guarantee yours is one of a kind. It's also a reflection of your artistic style and a way to shout—I AM AN ARTIST!

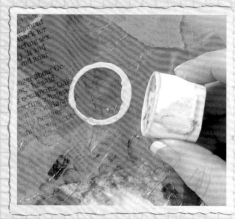

1. Remove the backing paper from the contact paper and lay it on the work surface, sticky side up. Tear strips and squares of tissue paper, colored paper, and newsprint and decoupage these to the contact paper in a pleasing layout.

2. Stamp shapes and other interesting pattern with paint and inks. Collage any clip art or photographs that you would like to add to the design. Make a decorated area around 15 x 4in (37.5 x 10cm). Allow to dry thoroughly before moving onto the next step.

3. Cut a 4½ x 3-in (11.5 x 7.5-cm) rectangle from a piece of paper as a pattern and use this to cut three pieces from the collaged paper sheet. Slightly round the corners and shape the sides so that the rectangle has no perfectly straight lines. Cut out the center of one of the pieces and stitch around the edge of the opening twice.

materials

Clear contact (sticky-back) paper

Tissue paper or colorful paper torn from various magazines

Newsprint

Decoupage medium

Objects to create interesting stamped shapes

Clip art, pictures, or rub-on transfers (optional)

Scissors

Round paper punch

Sewing machine or needle and thread

Craft adhesive

strips of colored fabric ½in (1cm) wide

Buttons or other embellishments

Linda Peterson
123 Creativity Lane
Artistville AL 12345

4. Lay the frame piece that you have just created on top of the remaining two pieces and stitch around the outside edge, leaving one end open. Punch a hole in the corner of the tag.

5. Fold the narrow strip of colored fabric in half and push the loop through the hole in the tag. Thread the ends of the fabric strip through the fabric loop and pull tight.

6. Glue on the felt button and then add the ordinary button on top. Add any extra embellishments you desire around the tag.

HElPFuL HiNTs

Making your own collage paper is an easy technique that I find to be very liberating creatively. There are no rules. Remember: sometimes art goes through an ugly stage before it gets finished and turns into something you like; work through this and don't give up.

To help you with color selections, look through magazines and take note of colors that the magazine designers group together. Tear out the pages of colors that personally speak to you and keep them in a binder. They make excellent color studies and will give you a quick boost when making color selections.

Create smaller versions of the tag to use as a miniature picture frame to put on your key chain or hang from your purse.

To create different looks, use contrasting colors of thread. Hand stitching gives a whole different effect than machine stitching.

Scan fabric into your computer or take a picture before cutting. Use your photo-editing program and then use the photos to create interesting backgrounds for additional art projects.

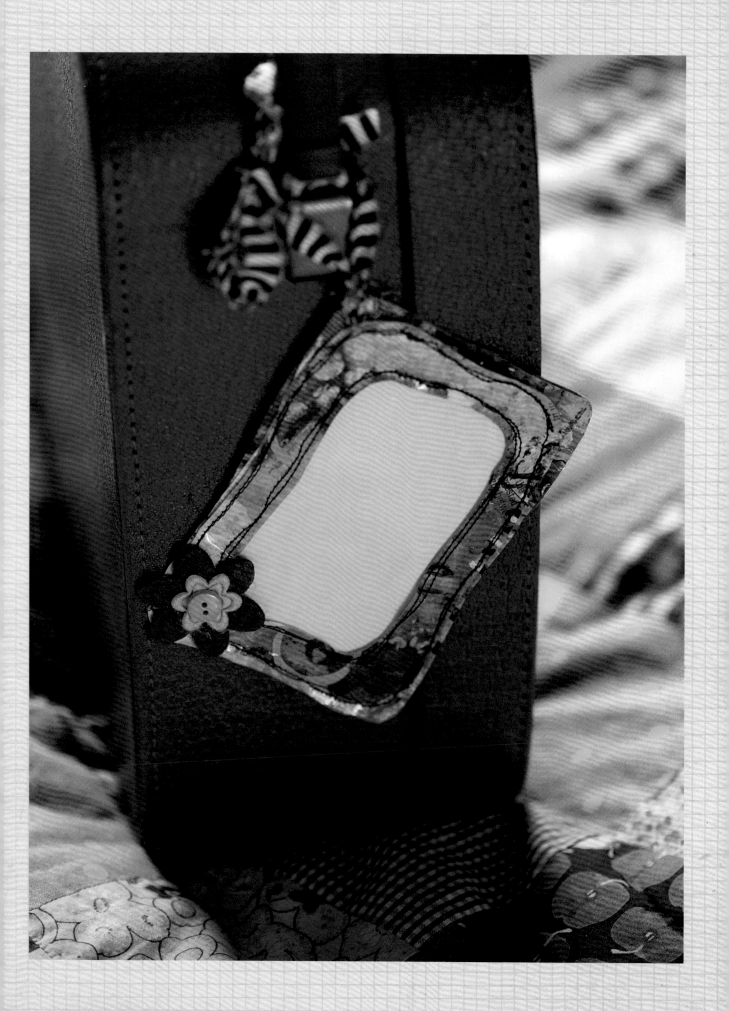

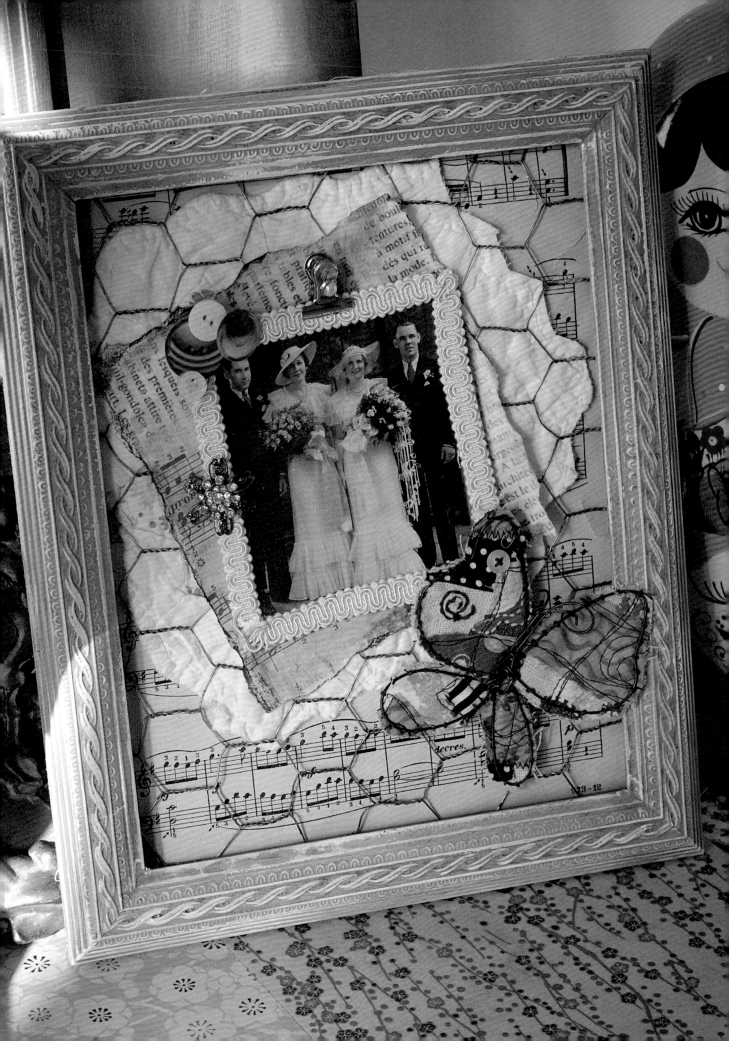

WiRE FrAMe mEmOry bOaRd

This frame makes a great "memory board" collection point in which you can attach all sorts of meaningful memorabilia such as concert tickets, brooches, photos—or use it to display your ATC (artist trading card) collection.

materials

Decorative wooden frame

Acrylic paint

Paintbrush

Piece of chicken wire

Staple gun and staples

Scrap of quilt

Pages of sheet music

Fabric collage—made from scraps of fabric sewn onto muslin (calico)

Sewing machine or needle and contrast thread

19-gauge/0.9mm annealed steel wire

Round-nose pliers

Wire cutters

Contrast embroidery floss (thread)

Decorative trim

Vintage photo

Craft adhesive

Selection of miscellaneous embellishments such as old buttons, brooches, or anything personal

Binder clips

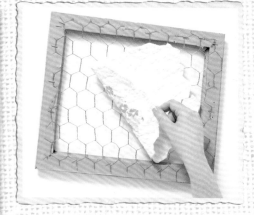

1. If necessary, paint the frame in a coordinating color to your fabrics. Cut the chicken wire to size and attach it to the back of the frame using a staple gun. Arrange the scrap of quilt behind the chicken wire.

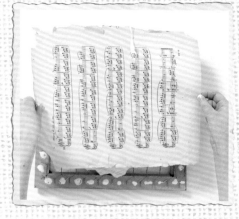

2. Lay the page of sheet music over the back of the frame over the scrap of quilt and glue in position. Trim away any excess paper around the edges of the frame.

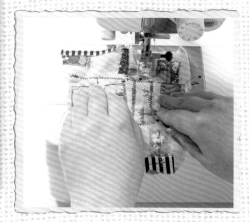

3. Create a collage of fabric pieces on the muslin (calico) and stitch in place, using contrast thread in the sewing machine. Create a butterfly shape with wire, stitch to the fabric collage using contrasting embroidery floss (thread),and then cut out (see page 31).

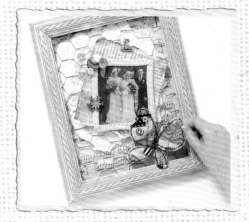

4. Glue four lengths of trim around the edges of the vintage photograph. Arrange the photograph and all the embellishment elements on the front of the memory board and secure with glue and binder clips.

HElPFuL HiNT

You could substitute an old window frame to make a much larger version of this project.

FLoWeR PoWeR

This project is also a good one for color study—why not try using two colors that you wouldn't normally use? Often when I work I find myself gravitating to the more neutral tones and palettes and then really piling stuff on; it's a challenge for me sometimes to keep things simple. Here colorful combines with simple to make this fun, bright, and cheerful flower power canvas.

materials

- Sheets of old music
- Decoupage medium
- Paintbrush
- 6 x 12in (15 x 30cm) canvas
- Acrylic paint in orange, blue, white
- Color wash in ocher, green
- Objects to create texture
- Fine-line black permanent marker
- Scrap of muslin (calico)
- Scissors
- Embroidery floss in red, green
- Embroidery needle
- Rice paper
- Scraps of red patterned fabric
- Craft adhesive
- Wooden rule
- Baby wipes
- Old buttons

HElPFuL HiNT

Old sheet music is readily available at thrift (charity) stores and flea markets. Instead of using the originals, scan the images into your computer and use the printouts.

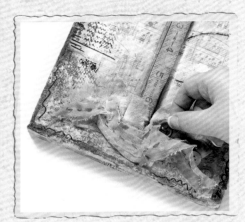

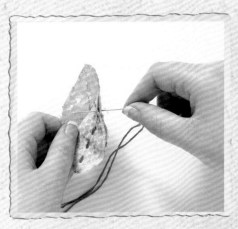

1. Decoupage the sheet music onto the canvas and allow to dry. Apply paint and texture layers to create a background (see page 26). Paint a white circle background for the flower and go around the edge of this with little "x" marks using the black marker.

2. Dye the muslin (calico) green with the color spray and cut out one or two leaves. Stitch down the center of each leaf in contrast embroidery floss (thread) using a running stitch. Cut concentric circles out of rice paper, muslin, and red fabrics for the flower head.

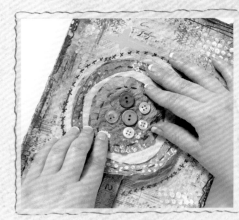

3. Glue on a section of the wooden rule to make the flower stem. Add the leaves to one side. Scrumple up some of the muslin, and glue onto the bottom of canvas. Glue or stitch on the baby wipe flowers and add other embellishments as desired.

4. Layer the circles for the flower with a red fabric piece on top. Glue on some buttons in a random layout in the center of the flower head and stick the flower head in place on the canvas. Add any final details to the artwork using the permanent marker.

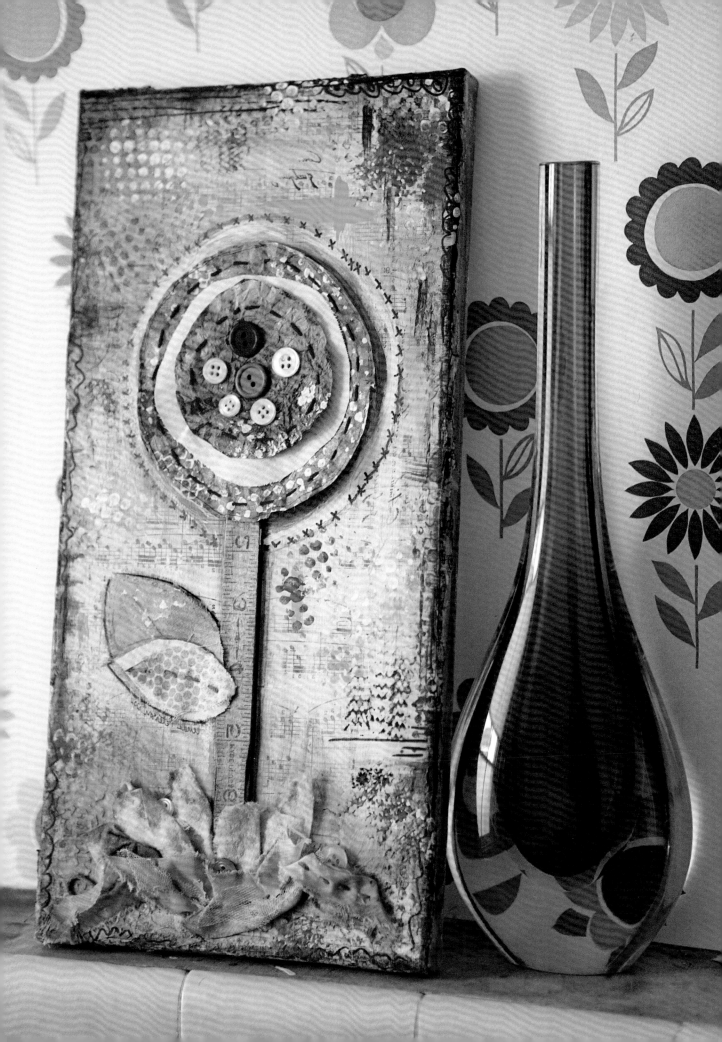

PostCarD fRoM PAriS

I took a photograph of the Eiffel Tower on my trip to Paris and wanted to turn it into an artwork to remind me of what I felt when I saw this famous landmark for the first time. The long narrow canvas—a postcard shape on its end—fits the shape of the image so this is my own "Postcard from Paris"!

materials

- Color wash in ocher, green, blue
- Paintbrush
- 6 x 12in (15 x 30cm) canvas
- Bubble wrap, shelf liner, and other objects to create interesting texture
- Large photograph of the Eiffel Tower
- White tissue paper
- Freezer paper
- Iron
- Matte gel medium
- Miscellaneous script writing stamps
- Alphabet stamps
- Black permanent stamp pad
- Timepiece stencil
- Molding paste
- Popsicle stick
- Gold paint stick
- Distressing inkpad in red, ocher
- Old credit card or palette knife
- Glossy decoupage medium

1. Spray blue and green color sprays toward the top of the canvas and ocher on the bottom, and use water and a brush to blend them together slightly. Drip daubs of water to create watermarked effects, and add texture as described on page 26. Allow to dry completely.

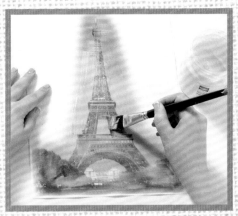

2. Alter the photo if necessary in a photo-editing program. Iron tissue paper onto freezer paper and cut into a suitable size to fit through your printer. Print out the photo on the tissue paper. Apply gel medium to the front of the tissue paper and allow to dry.

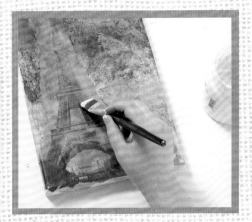

3. Carefully peel the tissue paper off the freezer paper backing. Tear the edges to help conceal the join after applying to the canvas. Paint the back of the image with gel medium. Apply the tissue photo to the canvas, adding more gel medium over the top.

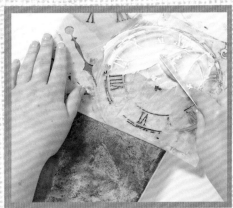

4. Stamp in the words "La Tour Eiffel" where desired. Stamp on any additional images with black ink. Lay the timepiece stencil where desired and apply a little molding paste over the top, using a popsicle stick.

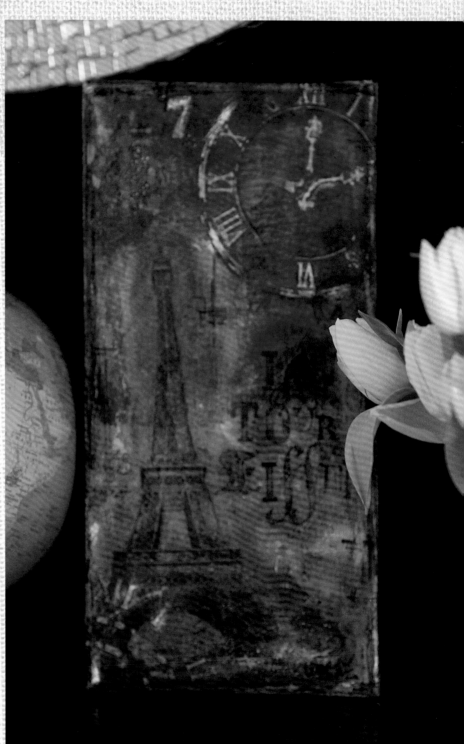

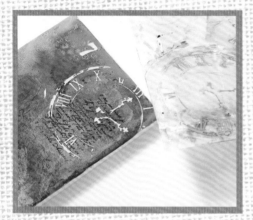

5. Lift off the stencil, being careful not to smudge the raised image, and allow the motif to dry completely. Repeat this technique as necessary to add a little three-dimensional texture where desired.

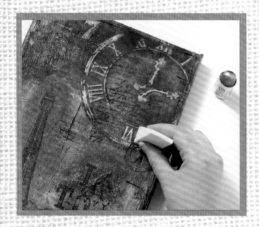

6. Carefully add a little gold with the paint stick to the high points of the molding paste motifs. Add black distress marks around the edges with a credit card (see page 30). Seal the finished artwork with a thin layer of glossy decoupage medium.

HElPFuL HiNTS

Use caution when running specialty papers through your printer. If you have any concern, you can substitute an ordinary photo or stamp directly onto the tissue paper with a large rubber stamp of your choice.

Stamp blank tissue paper with script images and tear out—this allows you to try out stamps and positioning before committing them to your canvas.

BEacH ToTe

Artistic play is an important part in the development of your skills as an artist and is also a great stress reliever. I discovered this texture when playing with heating Tyvek fabric. The texture reminded me of a tortoise shell and I knew immediately that I wanted to decorate a tote with the turtle and some shells I collected from the beach while on holiday.

materials

- Tote bag to decorate
- Piece of muslin (calico) slightly smaller than the bag
- Piece of plastic feed sack slightly smaller than the muslin (calico)
- Needle and embroidery floss (thread)
- Acrylic paints in turquoise, blue, green, ocher, burnt umber, white
- Paintbrushes
- Color wash in fuchsia, bright pink, orange, ocher
- Items to make texture and to stamp
- Black marker
- 10-in (25-cm) square of Tyvek fabric
- Heat gun
- Template on page 125
- Coarse-weave gauze or cheesecloth
- White craft glue
- Water
- Scraps of patterned fabric in greens
- Seashells
- Miscellaneous pearl and blue glass beads
- 2 or 3 disc beads
- Gold glitter glue pen

1. Cut the muslin and feed sack to fit your chosen bag. Turn the piece of feed sack so the inside white side is facing upward and hand stitch it to the muslin, using embroidery floss (thread). Create your basic background with color and desired textures (see page 26). Paint the Tyvek with ocher-colored acrylic paint, allowing some white to show through. Let dry.

2. Flip the Tyvek over to the unpainted side and apply heat to crumple the fabric and texturize. The fabric will begin to crumple up and shrink. Repeat the heating process, working over the entire area, until you have created the desired texture. Allow to cool completely before moving on to the next step.

3. Turn the Tyvek over and spritz with ocher color wash. Apply some burnt umber paint to the raised area to add additional dimension. Using the template on page 125 cut out the body, legs, and head of the turtle.

4. Glue the feed sack ensemble to the tote bag. Glue the legs and head onto the turtle on the reverse side. Glue the turtle onto the prepared background as if he is swimming.

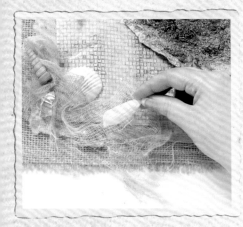

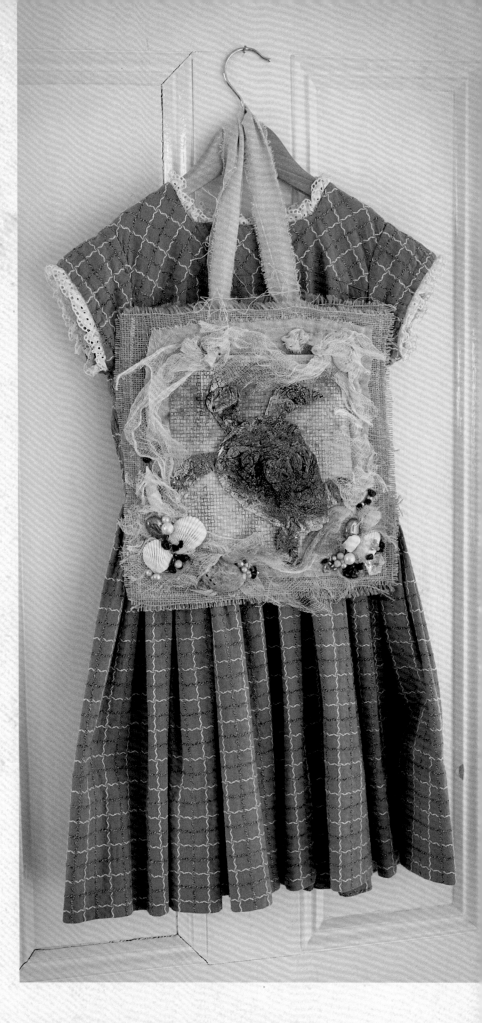

5. Dye the strips of gauze (see page 27)
and add them around the picture. Add
your choice of shells, beads, fabrics, and
any found objects to finish your image.
Add a little gold sparkle to some areas
using the glitter glue pen.

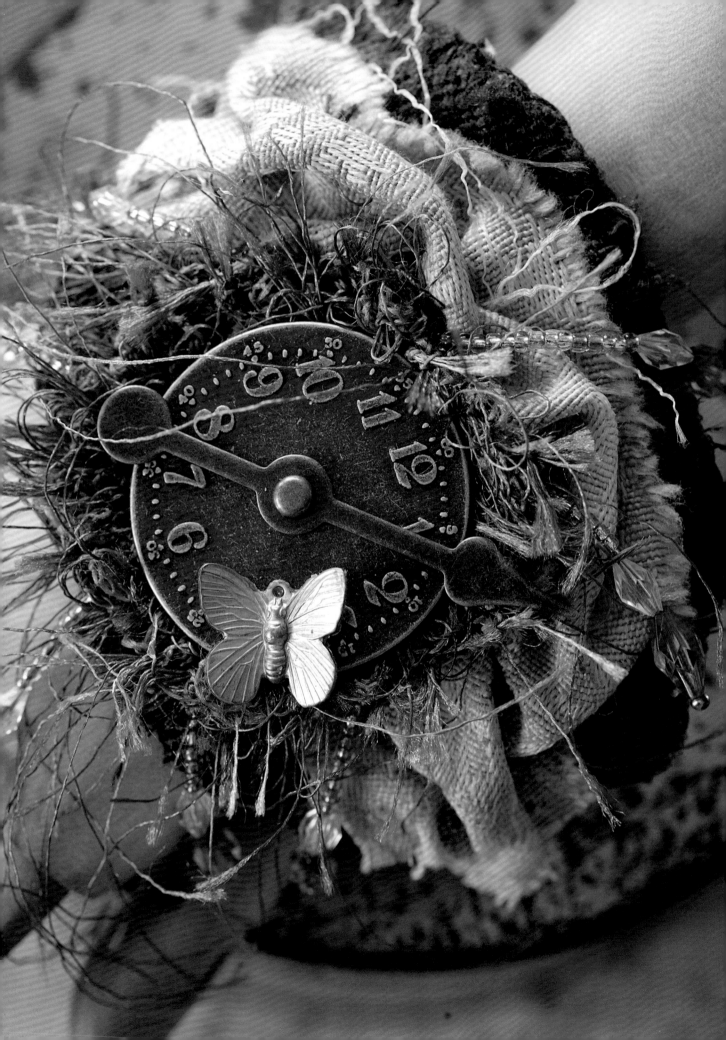

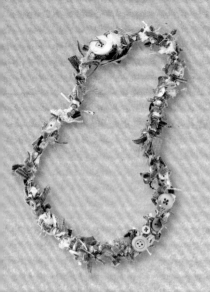

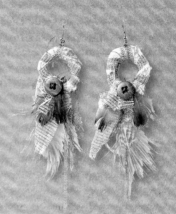

MiXed MEdIa JeWeLRy

Mixed media art comes in many forms. In this chapter, I have looked beyond the usual purpose for an object and combined it with jewelry findings to make art that you can wear. If you are short on time, or new to the mixed media experience, this is a great chapter for you to start as the projects will teach you loads of techniques to get you thinking creatively rather than realistically.

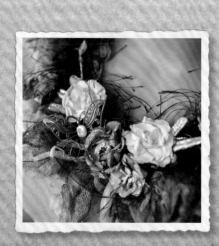

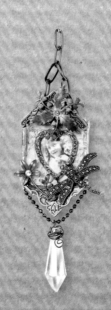

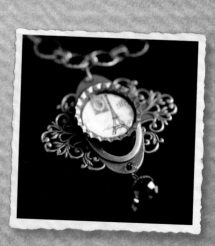

CARNIVAL RIDE

This pendant is reminiscent of my Mom and Dad as a young couple in love, when they frequented carnivals and fairs on their dates in the 1950s. It reflects the high spirits and colors of young love and fun times at the fair: the dice symbolizes the games of life, the ribbon a youthful free spirit, and the heart a love that has lasted over 50 years.

materials

- Soda can with interesting color or pattern
- Alcohol-based inks in colors of choice
- Cosmetic sponge
- Rubber stamp of choice
- Black permanent inkpad
- Double-stick tape
- Piece of aluminum sheet
- Scissors
- Hole punch
- Eyelet
- Hammer
- Bench block (optional)
- 24-gauge/0.5mm non-tarnish silver wire
- Round-nose pliers
- 1-in (2.5-cm) length of narrow rubber tubing
- Two silver spacer beads
- Heart charm or charm of choice
- Dice finding
- 3-in (7.5-cm) length of ribbon in color of choice
- Ball chain to required necklace length with clasp

1. Cut out your desired pendant shape from an interesting print area of the soda can. Apply some areas of color across the front surface of the pendant, using the alcohol-based inks and a cosmetic sponge.

2. Stamp an image on the pendant, using black ink. Offset the image on the pendant to add interest. Apply double-stick tape to the back of the pendant and stick to a piece of aluminum. Cut out the shape and trim the layers flush.

3. Punch a hole near one end of the pendant. Set an eyelet into the hole, using the hammer on a hard surface. Wrap a loop around the top to hang the pendant and then wire wrap along the length as desired.

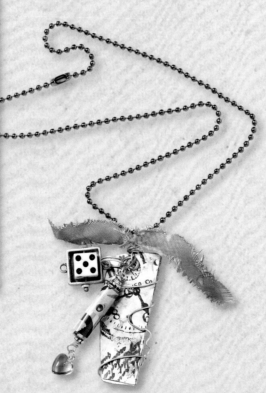

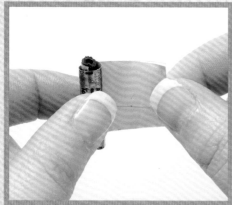

4. To create the tube bead, cut a rectangle from the can and stamp and ink as desired. Place double-stick tape on the back, then wrap around rubber tubing. Press the end to secure and trim off any excess tubing.

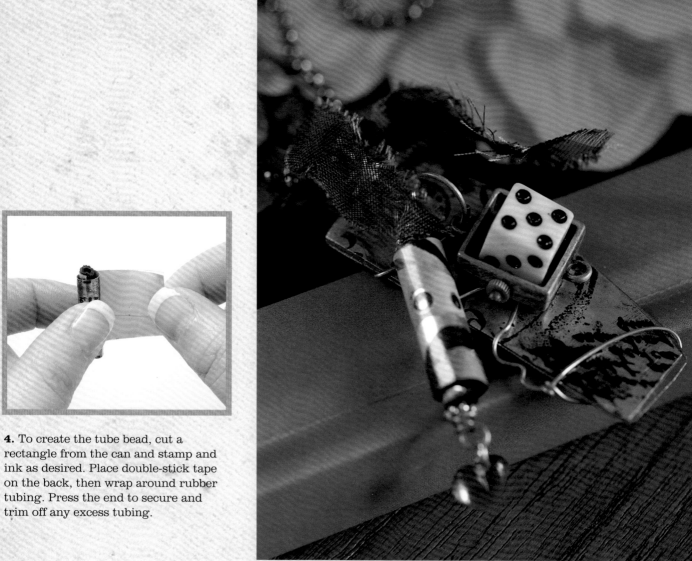

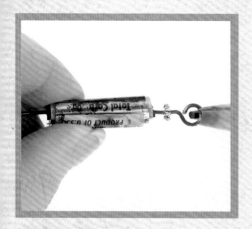

5. Create a loop from a length of wire, using round-nose pliers. Thread on a spacer bead, the tube bead, and another spacer bead. Loop the opposite end of the wire to secure.

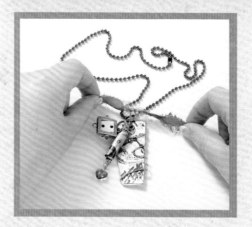

6. Attach a heart charm to the bottom loop. Attach the bead and dice to the top of the pendant with jump rings through the eyelet. Thread a short length of ribbon through the eyelet to add the pendant to the ball chain.

BE my HeaRT

Vintage Victorian jewelry is often quite chunky but also wonderfully detailed, and often incorporated photographs, lace, and other mementoes—which, of course, is a form of mixed media. I love this organic look of swirling leaves and flowers combined with the delicate movement of swinging chains, all set against the symmetrical curve of the heart and the very linear lines of the frame.

materials

Vintage photograph	Ball chain
White craft glue	Vintage charms
Heart charm	Small 2mm rhinestones or Swarovski crystals
Page from an old book	
Scraps of lace	Silicone-based jewelry glue
Two 1-in (2.5-cm) square glass tiles	Crystal from chandelier
Copper tape	24-gauge/0.5mm non-tarnish silver wire
Flux	
Solder	Short length of vintage cable chain
Solder iron	
2 jump rings	

1. Glue an open-heart charm over the focal portion of the image as if to frame it. Cut out around the heart shape and then glue onto the book page. Add a little piece of lace around the heart. Sandwich the collage between the two glass tiles.

2. Hold the sandwich firmly between your fingers to keep everything in place, and wrap a length of copper tape completely around the edges. Cut off any excess copper tape.

3. Press the edges of the tape down over the front and back face of the glass tiles. Apply a thin layer of flux all over the tape to allow the solder to flow smoothly. Apply the solder to the solder iron.

4. Use the tip of the solder iron to "paint" the solder over the copper tape to secure the tiles in place. Solder the two jump rings at either end of the top edge and a short length of ball chain to hang in a loop from the bottom.

5. Glue on a selection of vintage charms and rhinestones using silicone-based jewelry glue. Wire wrap the top of the crystal and attach to the center of the hanging ball chain. Add the ends of the cable chain to the jump rings soldered on the top of the pendant.

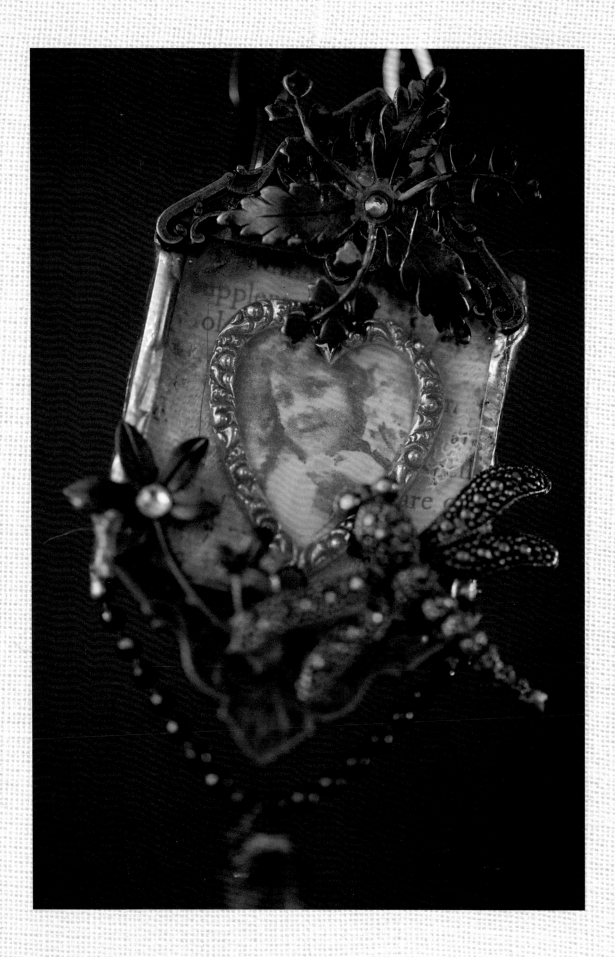

STeAMpunK COutURe brAcelET

I am especially fond of vintage elements and steampunk style. I wanted to make a bold design that combined masculine elements with a delicate feminine feel. I gathered items that I simply liked, thought were interesting, or had a nice texture and laid them on the table. Even though I didn't use all these, they allowed me creative playtime in which to arrange and rearrange elements. The softness of the textiles offers a contrasting background for the hard clock parts. Train yourself to look at elements this way, attributing "feelings" to them and then using them in this way in your design.

materials

Template on page 125

4 x 7in (10 x 16.5cm) piece of tapestry fabric

Scissors

Embroidery needle

Embroidery floss (thread) to match the tapestry fabric

2 x 6-in (5 x 15-cm) strip of brocade fabric

Needle and sewing thread

Craft glue

Clock face

Beaded trim

Butterfly finding, or any other embellishment of your choice

Small brass brad

Arrow spinner

Small open gear wheel

Tim Holtz Ideology trinket pin

HelPFuL HiNt

This bracelet fastens by hooking the trinket pin over the arrow spinner, but if you prefer you could stitch on a more conventional clasp.

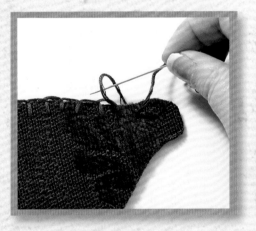

1. Copy the template on page 125 and use it to cut two pieces of fabric. Place the pieces wrong sides together and stitch all around the edges using embroidery floss and a blanket stitch.

2. Gather the piece of brocade into the center of the bracelet to create a ruffle effect. Secure the ruffle in place by stitching it to the bracelet.

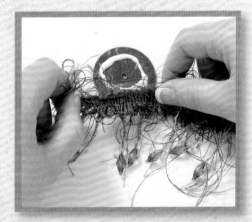

3. Apply craft glue to the reverse of the clock face and press the beaded trim around the edge. Glue on the butterfly embellishment. Glue the finished clock face to the front of the bracelet.

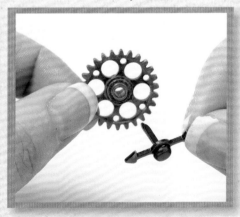

4. To create the clasp, thread the brad through the center hole of the spinner. Thread this brad through the hole of the gear. Stitch the gear in place on one end and the trinket pin on the other.

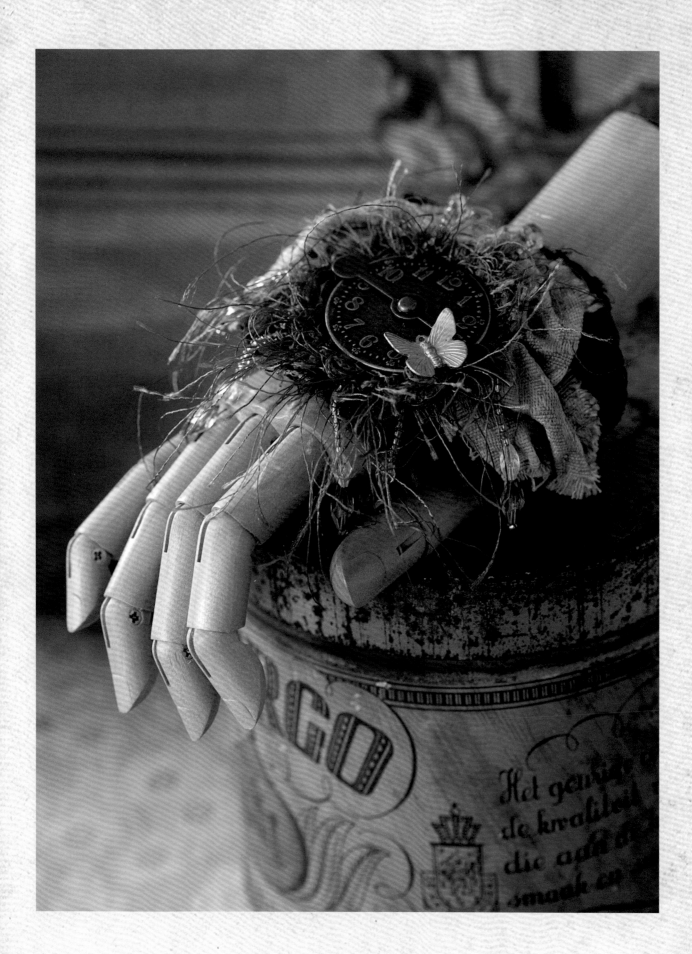

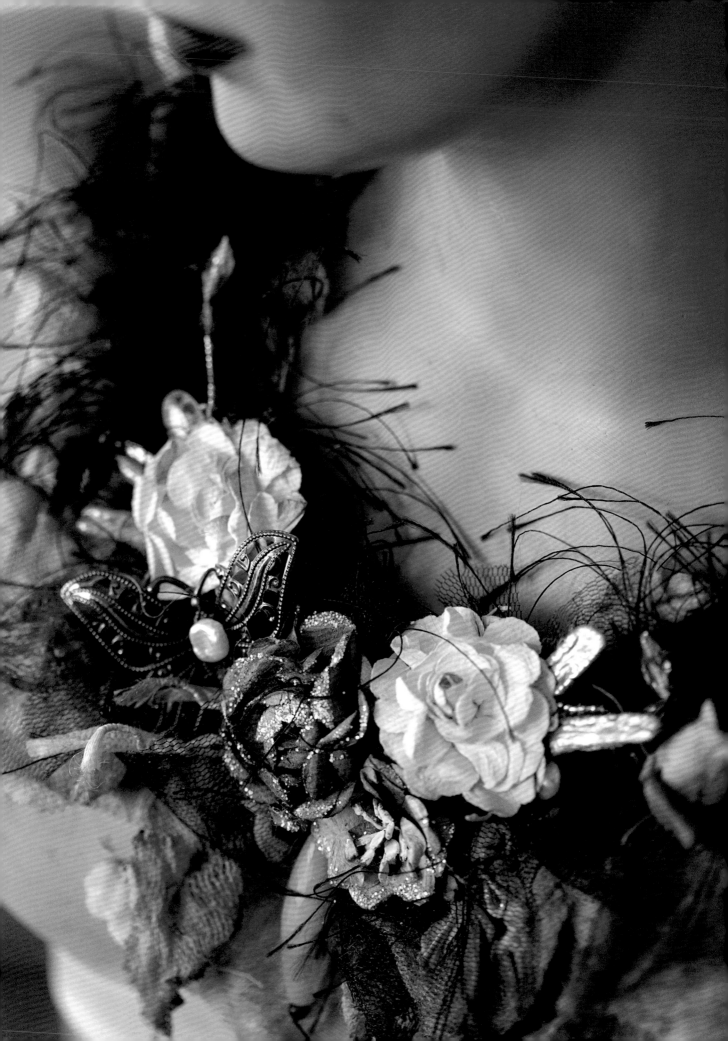

ENCHANTED EVENING

Imagination is a great thing; it can transport us anywhere and let us be anything we want. Imagine a glitter-filled world where your cares are as light as the wind. A world full of bright sunshine and beautiful flowers, a world you never have to leave. I used beaded eyelash trim to represent the wisps of wind and glittered flowers to represent sunshine and color-filled days. Use your imagination and then consider what textures you would use for each piece.

materials

Scissors

Open weave gauze or cheesecloth

Color wash in blue, green

Craft glue

Bowl of water

Non-stick work surface

40in (100cm) fiber trim

16 x 1-in (40 x 2.5-cm) strip of dyed fabric

Tulle in a coordinating color

Needle

Thread in coordinating color

Black beaded eyelash trim

Paper flowers

Vintage charms and findings

Miscellaneous beads of choice

1. Cut the gauze into random leaf shapes, spray with green and blue color wash, and allow to dry. Create a mixture of the glue and water in a 1:1 ratio. Dip all the pieces into the mixture; some dye will bleed into the glue solution.

2. Scrunch up the wet pieces and set them aside to dry on a non-stick work surface. Repeat until all of the gauze pieces are dipped and shaped. Allow all the pieces to dry thoroughly before using them.

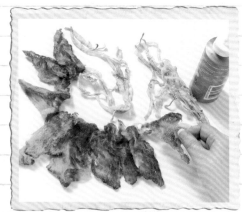

3. Double the fiber trim and lay down in a loop. Wrap the center 6-in (15-cm) section of fiber trim with the strip of fabric and secure the ends. Lay the pieces of shaped gauze onto the wrapped section, keeping shorter pieces at the ends and longer pieces toward the center. Glue in place.

4. Cut the tulle into random pieces of different sizes and shapes. Stitch or glue the pieces of tulle at irregular intervals on top of the gauze pieces on the necklace, so that they hang down among the leaf shapes in a pleasing manner.

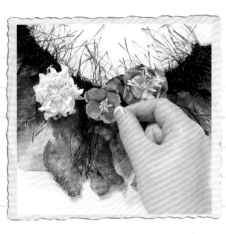

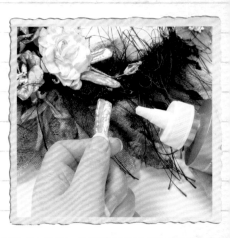

5. Cut a strip of black eyelash trim the same length as the decorated section of necklace and glue it over the top of the tulle pieces.

6. Arrange a selection of the paper flowers toward the center of the necklace. Secure with glue. Allow everything to dry.

7. Glue a vintage butterfly charm to one side of center. Finish by gluing on beads and charms scattered randomly between the flowers.

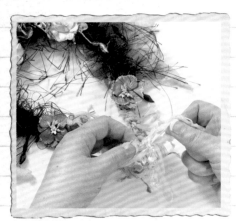

8. Add a flower on either side near the top of the necklace. To wear, gather the ends of the fibers together and tie in a bow on the back of the neck. The fiber length can be shortened or lengthened as desired.

HE1PFuL HiNTs

I generally take a quick digital photo of what I have laid out once it is arranged so that I can refer to it and replicate the pattern again.

You can either stitch or glue the pieces together to make this necklace. I prefer to stitch, because it fixes instantly and you don't need to wait for the glue to dry—you only need basic stitching skills.

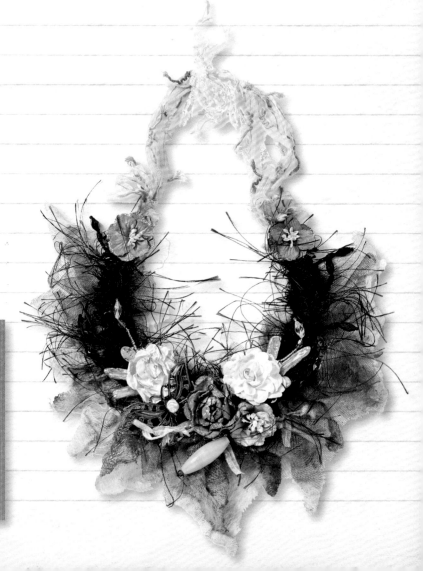

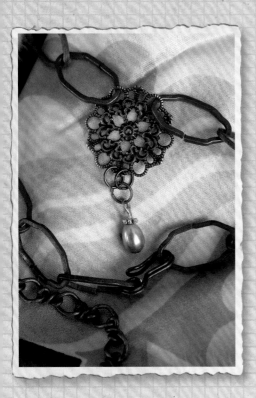

TImEPieCe LoCKEt PEnDAnt

Lockets were a favorite of my mother. On rainy days, I would get a very special treat of playing with her jewelry box. There was something special about her lockets, as they kept precious family photos near to her heart. When I found this vintage pocket watch pendant, I knew it would be the perfect way to keep a precious photo of my Grandma when she was a little girl. Combining it with a strip of lace and buttons helps me remember watching her sitting in her favorite chair and hand-sewing doll clothes for me. Going back in time helps my subconscious mind get into a creative mode. What is your subconscious mind expressing to you?

materials

- Old photograph
- Alcohol-based markers
- Locket assembly
- Old page from book
- Pencil
- Scissors
- Craft glue
- Decoupage flower motifs
- Piece of tulle or lace
- Miscellaneous small buttons
- Small foam pad (optional)
- Two-part epoxy glue
- 25-in (62.5-cm) length of large link chain with a hook fastener
- 17-in (42.5-cm) length of twisted link chain
- Small round filigree dangle
- Pearl bead dangle
- Jump ring

1. Colorize the area of the old black-and-white picture that you want to use, using alcohol-based markers. Don't use the original photo if it is irreplaceable—make a copy.

2. Remove the base from the locket and draw around the perimeter onto the book page using a pencil. Cut the shape out. Stick on the background embellishments.

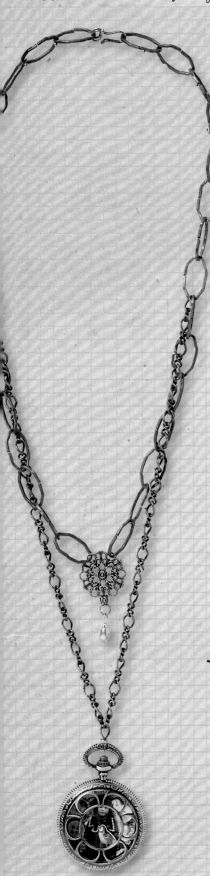

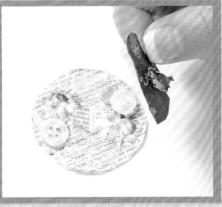

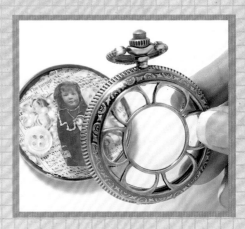

3. Cut out around the figure in the photograph and mount it on a foam pad for a more three-dimensional effect. Glue to the paper circle and then glue the circle inside the locket base.

4. Add a little epoxy glue to the edges of the front of the locket and carefully align over the base to stick in place. Leave the glue to dry fully before adding the locket to the chain.

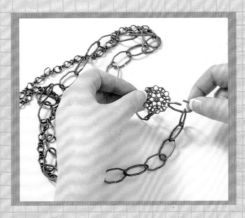

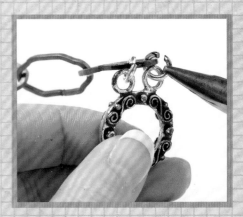

5. Open a link on the large link chain about halfway down on one side and add the end of the twisted link chain. Repeat on the other side so that the twisted link chain hangs slightly longer. Open a link on either side of the center of the large link chain and add the filigree dangle.

6. Add the pearl dangle to the bottom of the filigree dangle. Finally, use a jump ring to attach the locket to the center of the twist link chain, so that it hangs right at the bottom of the necklace.

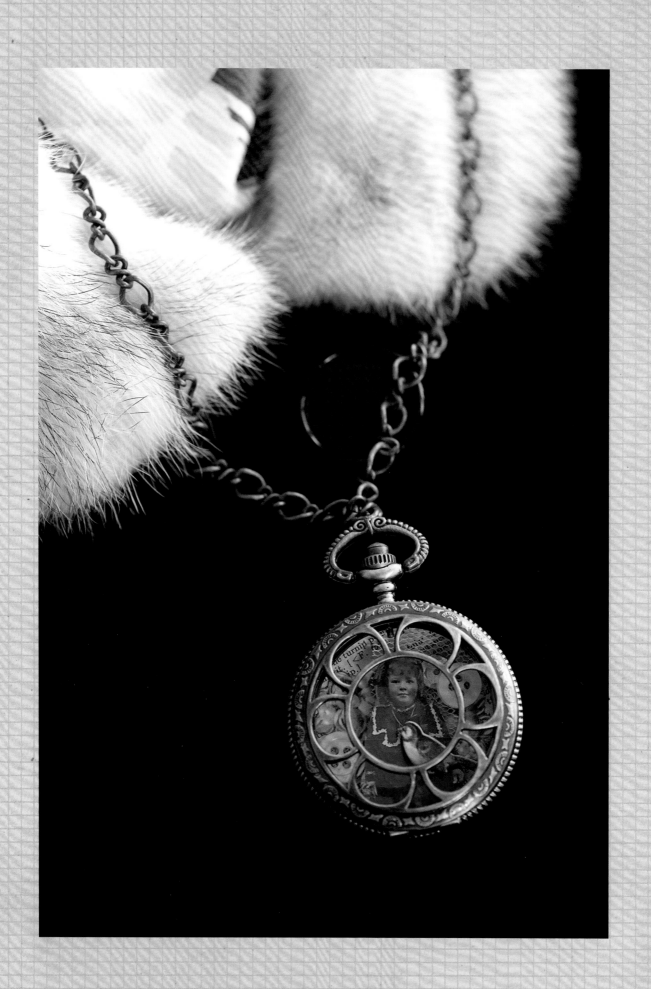

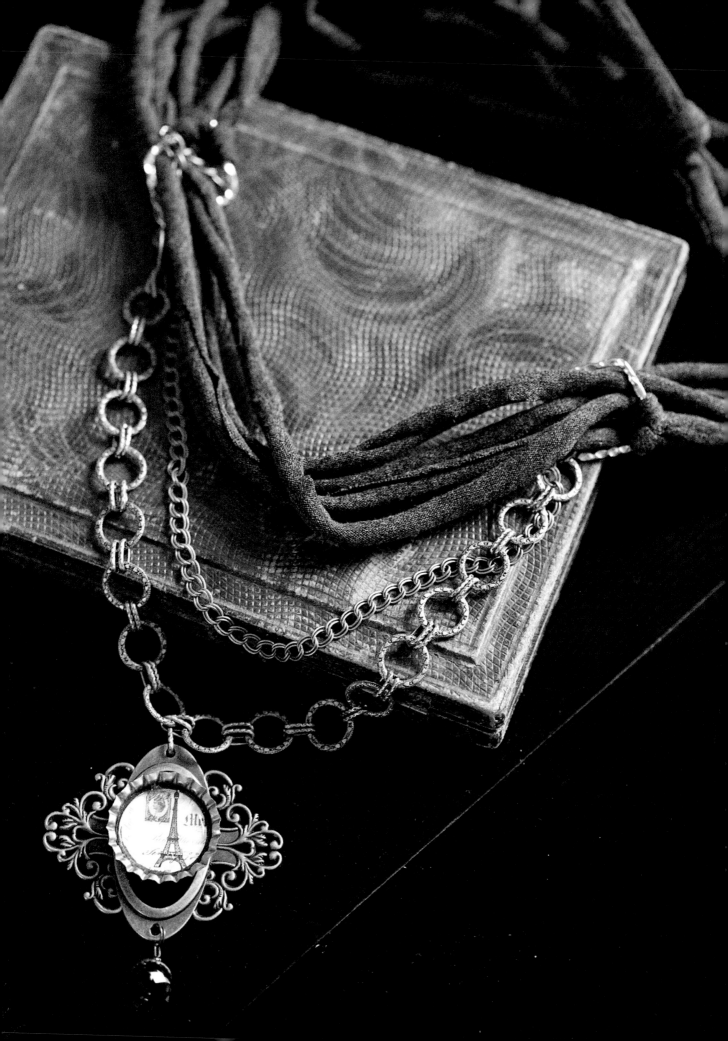

PAriS iN A DAY NEcKlacE

Traveling is a great source of inspiration when creating artwork. After finishing the photographs for my last book in London my editor, Marie, and I went to Paris for the day. Even though it was a short trip, we managed to pack in all the highlights of the city in that short time! This necklace commemorates that day.

materials

XL grey T-shirt with no side seams

Scissors

2 large decorative silver links

2 different lengths of chain, each about 12in (30cm)

Vintage picture

Clear resin sticker (page pebble)

Bottle cap

Vintage bookplate finding

Silicone-based jewelry glue

Bead dangle

2 jump rings

HElPFuL HiNTs

It's better to use a T-shirt that is woven in a tube than one with side seams to avoid a seam in the fabric rings. You could also use a white T-shirt and dye the fabric to any color desired.

Salvage chains from broken bits and pieces of jewelry to recycle into new items.

1. Cut three 1-in (2.5-cm) wide strips around a T-shirt near the hem to get three rings of T-shirt material. Stretch the fabric, causing the edges of the rings to roll inward. Gather two rings together and fold in half to make a semicircle.

2. Open a large silver link and thread on one folded end of the T-shirt semicircle. Attach one end of the accent chains to the silver link using jump rings. Repeat on the opposite end of the T-shirt semicircle.

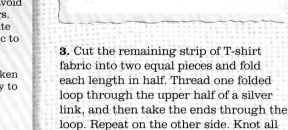

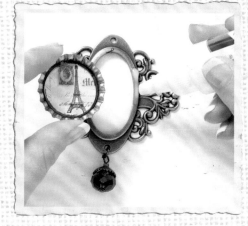

3. Cut the remaining strip of T-shirt fabric into two equal pieces and fold each length in half. Thread one folded loop through the upper half of a silver link, and then take the ends through the loop. Repeat on the other side. Knot all the ends together.

4. Cut a picture to fit inside the bottle cap (see page 30). Stick the bottle cap to the bookplate finding with silicone-based adhesive; allow to dry. Attach a bead dangle to the bottom of the bookplate with a jump ring and add the pendant to the center of the necklace using another jump ring.

FEatHeR EaRRInGs

Maybe I should have named these "fearless" feather earrings; the inspiration for them came from the longest pair of feathered earrings I have ever owned. I intended taking them apart and remaking them, but I tried them on and discovered I loved them and felt fearless as the feathers danced about. These earrings are inspired by that sense of fearlessness. Take a moment to find your fearless self and express yourself in these earrings, too!

materials

Thin black rubber tubing

24-gauge/0.5mm copper wire

Linen fabric or similar in neutral and contrasting colors

Scissors

Craft glue

Feathers of choice

2 buttons or other embellishments of choice

2 x 6-in (15-cm) pieces of silver chain

Needle

Thread to match contrast fabric

2 small silver jump rings

2 silver fishhook earring findings

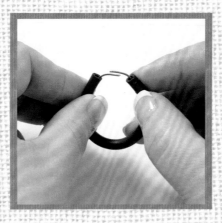

1. Cut a piece of tubing about 3in (7.5cm) long. Thread a length of the wire through it, leaving about ⅓in (1cm) extra on each side. Shape into a circle and thread the wire ends through the opposite ends of the tubing to create a ring.

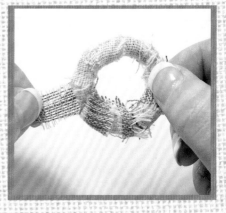

2. Tear strips of fabric about ⅓in (1cm) wide and fray the edges. Dip one end of the fabric in glue and wrap over the seam on the tube to secure. Continue wrapping fabric until the tubing is covered. Wrap the ring with contrasting fabric.

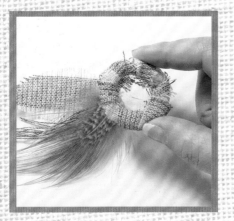

3. Cut a piece of the contrasting fabric roughly into a feather shape and fray the edges. Layer the real feathers on top to create a pleasing arrangement. Glue to secure, and then glue the assembly to the back of the ring.

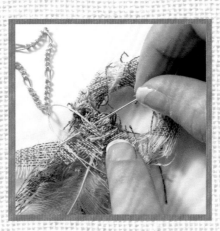

4. Fold the chain so that the ends are slightly different lengths. Stitch the link at the fold of the chain onto the back of the feather embellishment. Cover the stitching on the back of the chain with a small piece of fabric to finish off.

5. Stitch a jump ring to the top of the earring and use this to attach the fishhook finding. Glue on any additional embellishments. Repeat to make a second matching earring—or attach one to a chain or cording for a unique pendant.

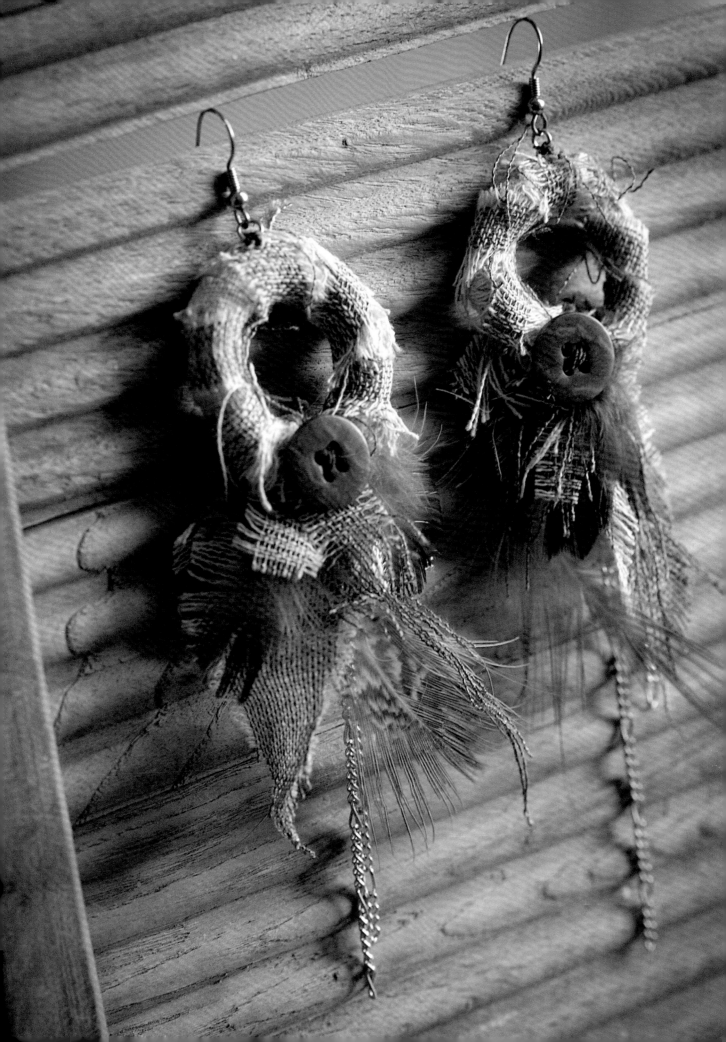

JeWelRy oN a SHoEStrIng

The inspiration for this necklace came from my Grandma's button box; it's a fascinating historical record, because she has been collecting odd buttons for years. I've also added some scraps of vintage fabric reminiscent of her scrap fabric and lace box, for an heirloom necklace that really is created on a shoestring... hopefully your family won't notice their missing shoestrings!

materials

Shoestring

Long torn strips of fabric

Embroidery floss (thread)

Scissors

Selection of buttons

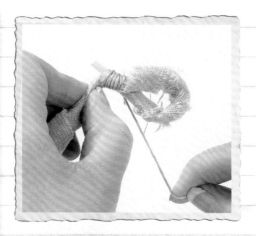

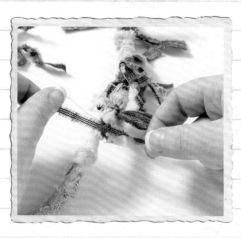

1. Wrap the shoestring along its entire length with a long strip of torn fabric. At one end, fold over the wrapped shoestring and bind in place with embroidery floss (thread) to create a loop for the necklace fastening.

2. Tie on short lengths of fabric along the entire length of the shoestring. Try to tear the fabric strips rather than cutting them so you begin to get a fraying effect on the edges that will add to the interest of the design.

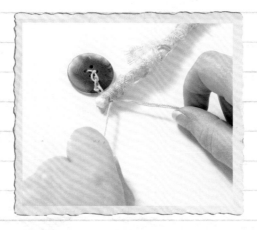

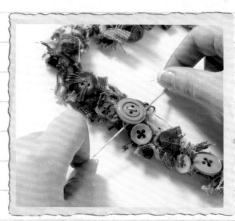

3. Using embroidery floss (thread), tie a button to the end without the loop to create the toggle. Make sure that the button will fit through the loop on the opposite side.

4. Fill in any gaps with miscellaneous buttons, tying them on with embroidery floss (thread) and fabric strips. You could add memorable charms, too!

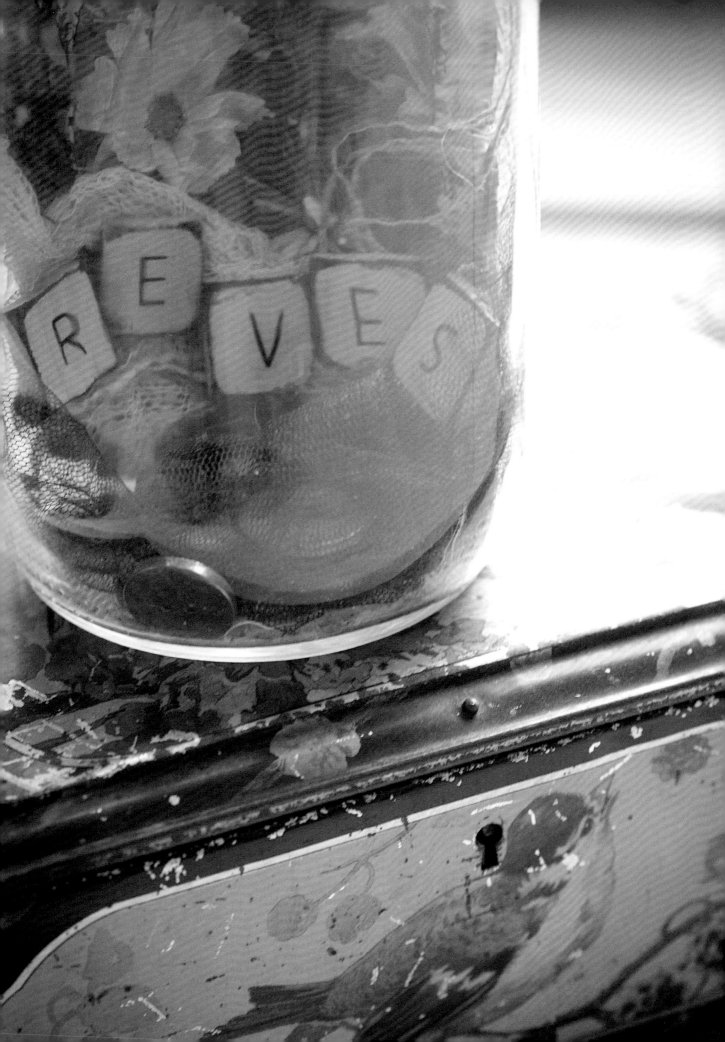

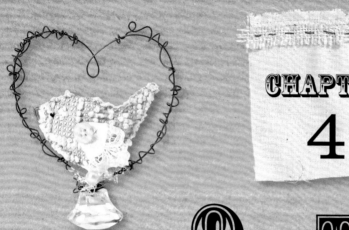

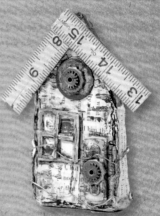

CHAPTER 4

OuT Of THe BoX

I don't know about you, but my life takes on many dimensions; it's never dull! Sometimes it's necessary to step out of our comfort zone or "out of the box" and think a little differently when we face a challenge. This principle can be applied to our artful life as well. Thinking creatively is important in shaping who you are and who you are as an artist. It is good to feel vulnerable and experience fear of the unknown when it comes to art. Don't be afraid to make mistakes: be fearless. This chapter will encourage you to think "out of the box": the projects are based on using ordinary, everyday items in a different way.

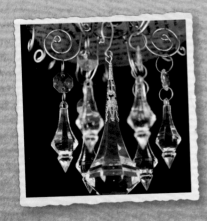

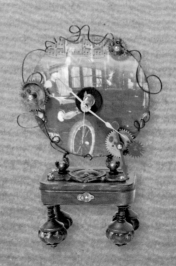

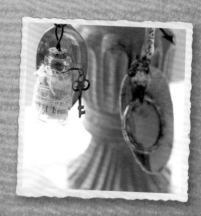

FAiRY DRessfoRm

Sometimes when life throws problems at me, I wish I could grow wings and fly far away. The reality is that it's impossible—but I can creatively grow wings and use art as a means of escape. I've had this papier mâché dressform in the studio for years and never knew quite what to do with it until I looked up and realized I had a collection of dressforms in all shapes and sizes—but I didn't have one with wings that could take me to far-away places!

materials

- Newsprint or vintage printed paper
- Decoupage medium
- Small papier mâché dressform
- Craft adhesive
- Tulle
- Dice
- Drill and drill bit
- Green drawer pull
- Crystal doorknob
- Strips of dyed fabric in green, ocher, pink
- Scissors
- Crochet lace doily
- Lace, buttons, feathers, or other embellishments of choice
- Filigree flower findings
- Heart crystal bead
- 19-gauge/0.9mm annealed steel wire
- Bottle cap
- Epoxy glue

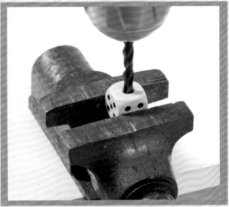

1. Decoupage some paper onto the dressform (see page 30) and glue a base skirt of tulle around the waist. Set aside to dry. Drill a hole through the dice.

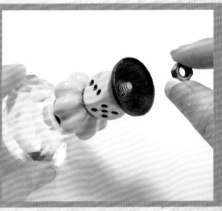

2. Thread the green drawer pull onto the screw thread of the crystal doorknob and stack on the dice and then the drawer pull cap. Add the nut to secure.

3. Lay the dyed strips of fabric in a line. Place a longer strip on top in the center. Fold the top of each short strip up over the center toward the top. This creates the double fringe of the skirt.

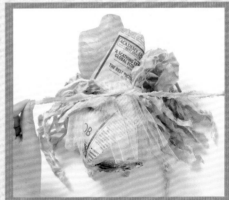

4. Tie the skirt on the doll. Make a bodice from a section of the doily and glue onto the top. Embellish the top as desired. Add a flat flower finding to the neck of the dressform and glue on the heart crystal.

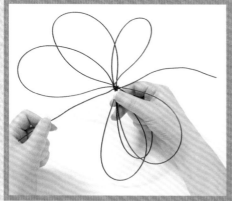

5. Make the wings from wire, leaving an extra length in the center. Dip the free end in adhesive and push into the back of the dressform. Finish by securing the dressform to the pedestal base permanently with epoxy glue.

HElPFuL HiNTs

I glued a bottle cap to the bottom of the dressform, which fits perfectly over the pedestal base so the dressform can be glued securely.

You could also cut the wing shapes from stiff tulle and glue them onto the back of the dressform.

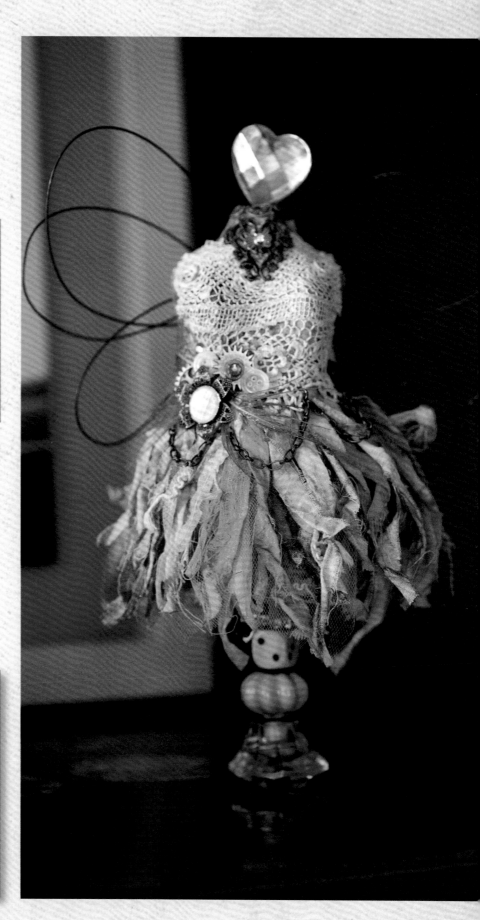

GArdEn MoBilE: BIrDCaGe

I was inspired to make this project when walking around my garden one morning; I thought a decorative cage hanging from an old, gnarled tree branch would be a great juxtaposition of man-made and natural. I wanted my cage to be really eye-catching—so I hung crystals from the base to catch the sunlight and flash color across the garden. My cage holds a wagon (see page 103) but you could put anything you like in yours!

materials

Pages from an old book

Decoupage medium

Old CD

Paintbrush/cosmetic sponges

Drill with 1¹⁄₁₆-in (2.7-cm) drill bit

1 roll 1¹⁄₁₆-in (2.7-cm) aluminum armature wire

Wire cutters

Basic jewelry pliers

24-gauge/0.5mm wire

2 large flower filigree findings

Two-part epoxy adhesive

Large crystal heart-shaped bead

Crystal chandelier ornament

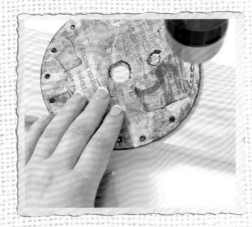

1. Tear the paper into random-sized strips and decoupage onto the front and back of the CD. Mark the placement for sixteen evenly spaced holes for the bars of the cage around the edge of the CD and carefully drill the holes.

2. Cut eight 16-in (40-cm) lengths of armature wire. Thread the end of a wire through a hole in the CD and curl with pliers to secure. Take the opposite end, bend over, and thread through the hole directly opposite. Coil the wire to secure.

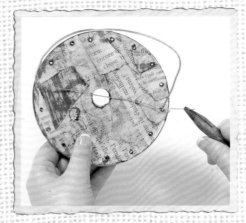

3. Take a length of the 24-gauge/0.5mm wire and wrap one end around the base of the cage bar just added. Run it straight across to the opposite side over the center hole and secure to the opposite cage bar.

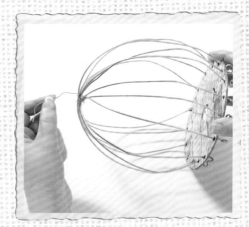

4. Add the remaining cage bars as in step 2. Gather all the bars together at the top point where they cross and wrap with a short length of the fine wire to hold all the bars in place. Use the end of the wire to create a loop at the top.

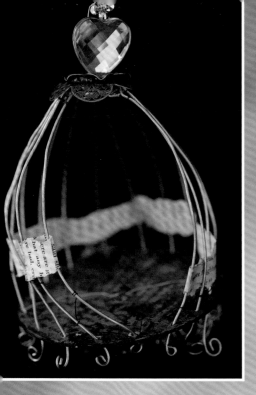

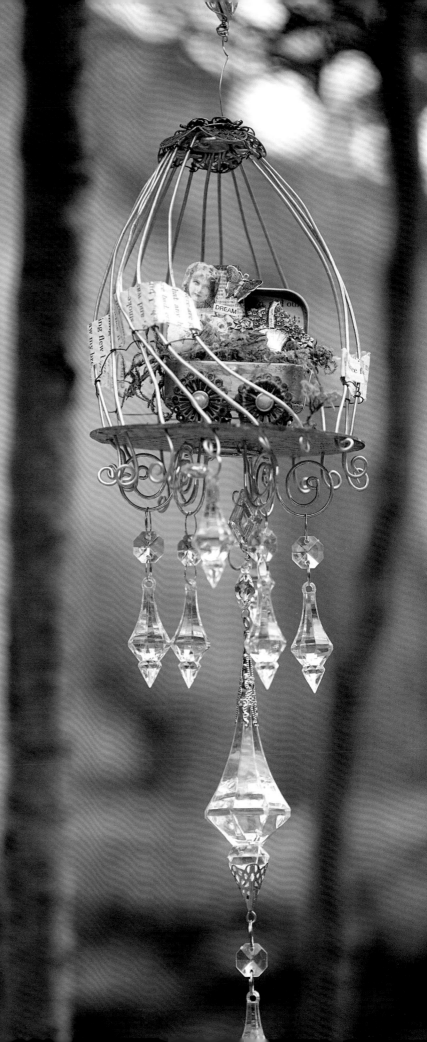

HElPFuL HiNT

Do not worry if you can't find exactly the same components as seen in the photographs of this project; choose your own items and memorabilia to make this project your own. The birdcage can contain anything you like—a different model, a small plant with trailing stems, or even a handcrafted bird!

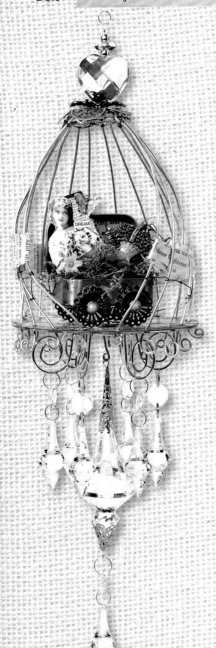

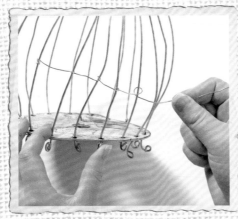

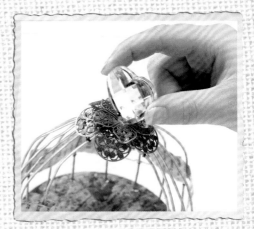

5. Bend two of the bars apart at what will be the front of the cage. Take a length of the finer wire and weave it in and out of the cage bars, working around from one side to the other but leaving the space between the two bars at the front open. Position the woven wire randomly, moving up and down the bars; the effect shouldn't look too symmetrical.

6. Glue the filigree flowers on top of the bird cage using epoxy adhesive. Glue the crystal heart on top of the flowers, again using the epoxy adhesive. Allow all the adhesive to dry thoroughly before adding the decoration to the base of the cage.

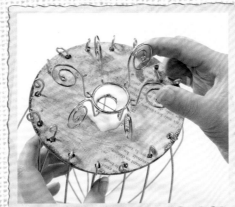

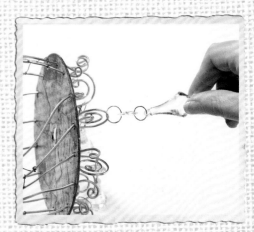

7. Remove the crystal dangles from the chandelier ornament. Glue the wire part of the chandelier ornament to the bottom of the bird cage, around the center hole, and set aside to dry thoroughly before proceeding.

8. Attach the dangles to the wire coils beneath the bird cage. Tear a narrow strip of the book page and weave this between the bars of the cage. The cage can hold any item, or you can make the wagon on page 103.

HElPFuL HiNTs

If you cannot source a suitable crystal chandelier ornament for the base of the birdcage, make up your own ornament using lengths of the armature wire and a few chandelier crystals or similar crystal beads.

GARdEn MoBiLe: VInTAge WAgOn

When I was a child, I had a little red wagon that I pulled my doll around in. I thought a miniature version of this would be a perfect complement to my birdcage project (see page 100). But it would work just as well as a stand-alone project in a shadow box. The contents of this wagon were inspired by gardens and gardening, sitting and listening to the songbirds.

materials

- Small Altoid or other mint tin
- Sanding block
- Alcohol-based inks
- Brush/cosmetic sponge
- Double-stick tape
- 4 round metal flowers with brads
- Page from an old book
- Decoupage medium
- Styrofoam®
- Scissors or craft knife
- Spanish moss
- Domino
- Vintage photograph
- Distressing ink
- Paintbrush
- Butterfly charm
- Flower basket finding
- Miscellaneous flower charms
- Craft adhesive

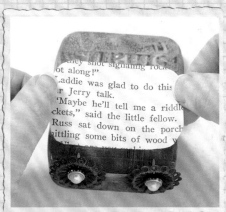

1. Gently sand the tin. Apply ink to the cosmetic sponge and gently colorize the wagon if desired. Apply double-stick tape to the underside of the tin and remove the backing. Thread the flowers onto the brads and place the arms of the brads on the tape on the underside of the tin to make the wheels.

2. Stick a piece of the old book page on top of the tape to conceal the ends of the arms of the brads. Trim or sand the edges of the paper so that they are level with the sides of the tin.

3. Decoupage a scrap of the paper to the inside of the lid. Cut a small piece of Styrofoam® to fit inside the base of the tin. The Styrofoam® won't be seen, so you could use up any odd scraps here left over from other projects.

HE1PFuL HiNTs

Substitute washers or vintage buttons for wheels if you can't find suitable findings, and feel free to add any additional embellishments to give this project personal meaning.

Glue small pieces to a toothpick and stick this down into the moss—this helps them to stand up easier.

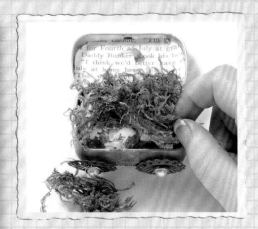

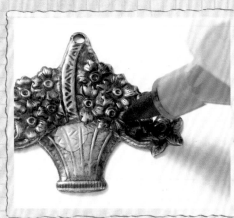

4. Fill the inside of the tin with a little Spanish moss. Distress the domino by lightly sanding and then decoupage the words and an image from the old book onto the front. Add a little distressing ink (see page 30). Glue on the butterfly charm.

5. Color in the flower basket finding as desired, using the alcohol-based inks, and place in the wagon. Add any other embellishments you choose.

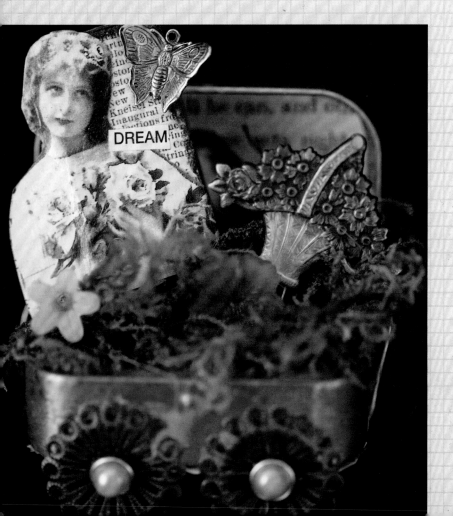

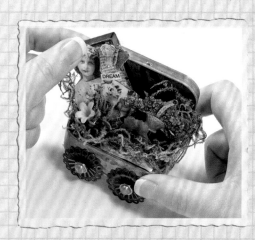

6. Arrange the domino and any other embellishments inside the wagon and secure with a dab of adhesive. Set the wagon inside the bird cage (see page 100) if desired.

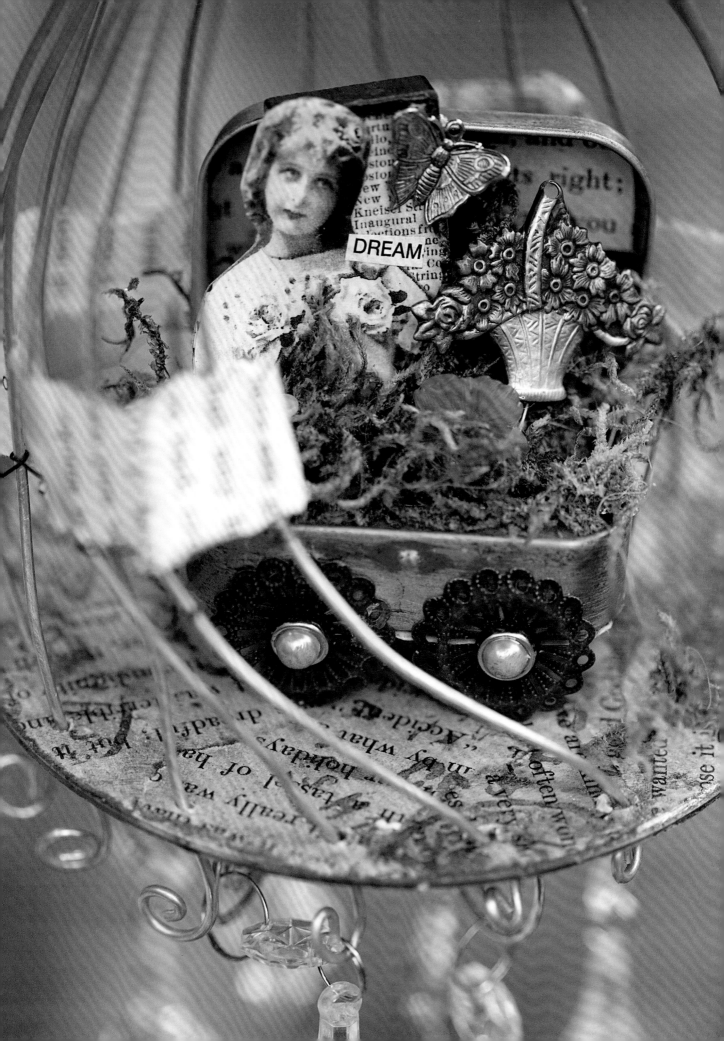

ALteREd HOusES: PApiER mAcHE

There's something so fun and textural about working with papier mâché. When I squeeze it between my fingers, it reminds me of walking barefoot on the beach when the sand washes between your toes. Gather supplies that are reminiscent of your childhood or of a fond memory and attach those to this project.

materials

- Paper mâché mix
- Pair of plastic rulers
- Gesso
- Paintbrush
- Decoupage medium
- Pages from an old book
- Scissors
- Acrylic paints in colors of choice, plus burnt umber
- Polymer clay in tan
- Pasta machine or brayer
- Template on page 124
- Craft knife
- Craft tool
- Small old photograph
- Thick craft adhesive
- Wooden extendable rule
- Sanding block
- Old washers
- Gears
- Numbers
- Bottle caps
- Fine-tipped permanent black marker
- Small piece of chicken wire, optional

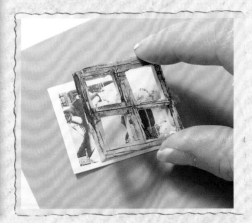

1. Mix the papier mâché according to the directions on the packet and form into a basic house shape. Press a pair of rulers on opposite sides to get the edges fairly straight. Allow the papier mâché shape to dry out completely before decorating—this may take some time for such a large, solid shape. Apply a coat of gesso to the surface and let dry.

2. Decoupage paper to the front of the house (see page 30). Apply a wash of color with paint. Flatten out the polymer clay with the pasta machine or brayer to approximately ⅛in (2mm) and use the template on page 124 to cut out a window with a craft knife. Add texture with a tool. Bake according to the manufacturer's instructions and leave to cool.

3. When the window shape is completely cool, add some distressing (see page 30) to the front and sides. Glue a photo behind the window, if desired.

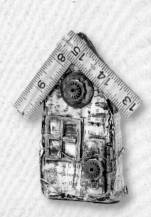

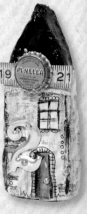

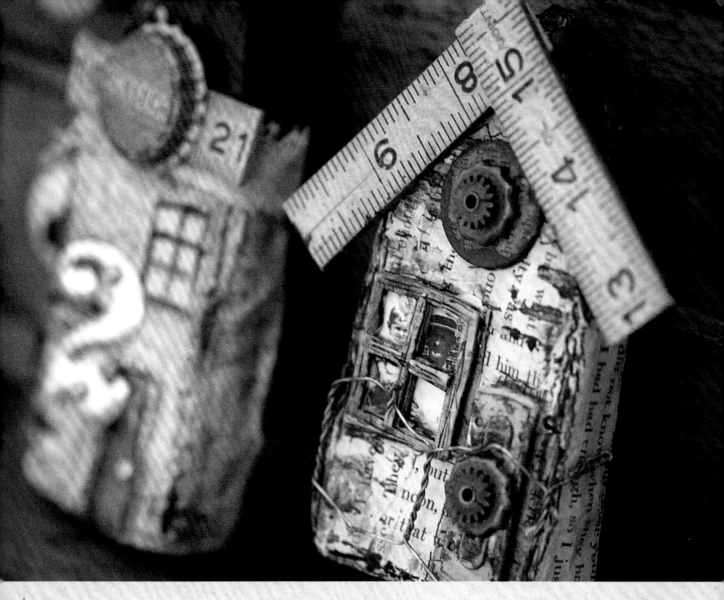

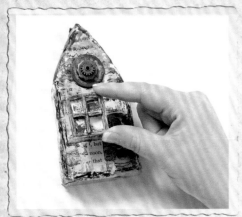

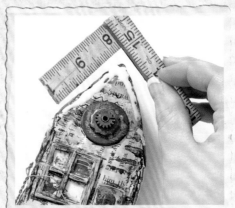

HElPFuL HiNT

When you have mixed the papier mâché create several shapes at a time for future projects. You can speed up the drying process by placing them on an oven-safe rack in an oven set to 150°F (65°C).

4. Add the window to the front of the house. Cut the tip from one section of the wooden rule, with the metal hinge still in place. Glue this to the house as the front door. Glue on a selection of washers, gears, numbers, bottle caps, and other embellishments to the front of the house as desired.

5. Cut sections of wooden rule to length for the pitched roof and sand the cut edges smooth. Overlap one piece over the other to create a V-shape and glue to the top of the house. Add decorative detail with a fine black marker. Wrap a small piece of chicken wire around the house if desired. Finish with a coat of decoupage medium to seal and protect the project.

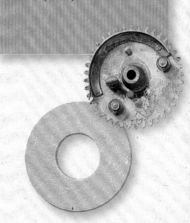

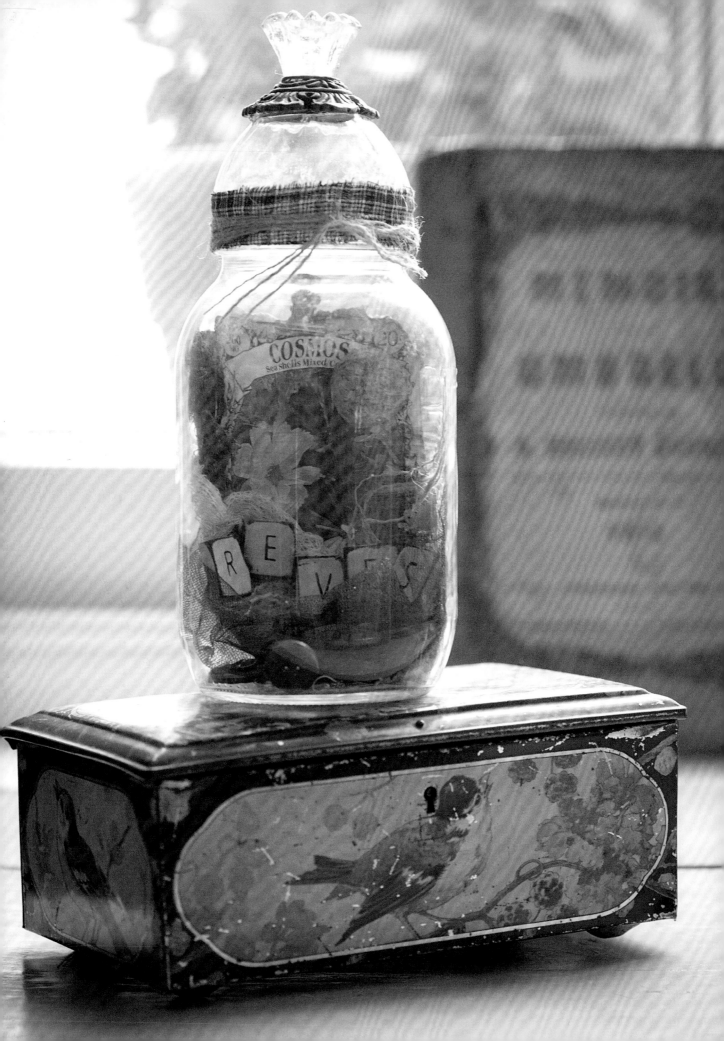

DReAMs iN A JaR

After creating one of the other projects I stared at my work table, wondering what to do next. My table was a mess, but it included my ever-faithful Mason jar of tea and an empty water bottle that I was going to use for something totally different. I thought of adding the top of the water bottle to the Mason jar; it created this gorgeous shape I knew I couldn't pass up. I added a vintage-looking but vibrant-colored seed packet; and I knew that these three—Mason jar, water bottle top, and seed packet—were meant to be together.

materials

Seed packet or photograph

3¼ x by 4-in (8.5 x 10-cm) piece of cardboard

Acrylic paint in brown, white, tan

Paintbrush

Decoupage medium

Pages from an old book

Stapler

Fabric pieces in coordinating colors

Scissors

Open-weave gauze or cheesecloth

Craft adhesive

Spanish moss

Sanding block

Wooden letters

Fibercast plaster

Face mold of choice

Brown tulle

Buttons of choice

Empty water bottle

Scissors

Clear glass Mason jar

Decorative drawer knob pull

Jute cord

1. Tear off the top of the seed packet as neatly as you can and remove the seeds. Reveal the texture on the cardboard (see page 30) and highlight the edges with paint or ink. Decoupage a book page to the reverse. Distress the paper if desired (see page 30).

2. Collage another book page and the seed packet to the front of the piece of cardboard at an angle, as shown. Staple random pieces of scrumpled fabric onto one side at the front of the seed packet.

3. Crumple up a length of gauze decoratively and glue this to the bottom front of the seed packet. Add a small piece of Spanish moss onto the gauze.

4. Distress the wooden letters, if necessary, with a sanding block. Add the letters on top of the gauze. Make up the molded face (see page 31) and stick onto the top right of the seed packet.

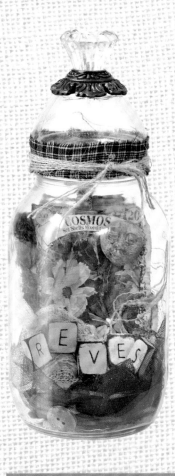

5. Place some tulle in the bottom of the jar and sprinkle with old buttons. Gently bend the cardboard collage and place inside the jar, arranging it with a pencil if necessary.

6. Cut the dome off the top of the water bottle using scissors and then cut off the screw nozzle. Trim with ribbon and then glue the dome to the top of the Mason jar.

HE1PFuL HiNTs

Train yourself to look beyond the obvious to see the potential when creating. Look at the object for its shape or for its texture.

Use whatever you choose as embellishment: old buttons from vintage shirts; vintage fabrics; lace. You may even want to exchange the seed packet for a favorite photo. Add decorative charms to enhance the theme and don't be afraid to use different words that will fit your personality better.

It would be fun to hand-write some of your dreams on a decorative piece of paper and tuck them inside the jar for safe keeping.

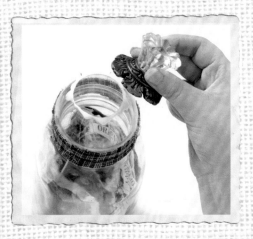

7. Glue the drawer knob pull to the top of the water bottle dome using craft adhesive. Allow to set completely.

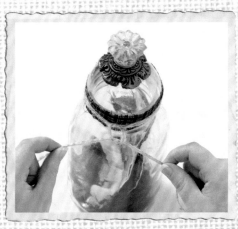

8. Wrap the Mason jar with strips of decorative fabric and embellish with jute cord and a knot.

sPoONs On A HAngeR

Odd spoons, or other odd bits of cutlery, are easy to come by in junk shops and yard sales and they are often very decorative. It seems a shame not to use them for something and give them a new lease of life—so here is one idea.

materials

19-gauge/0.9mm annealed steel wire

Section from an extendable wooden rule

Wire cutters

Craft drill with small drill bit

Decoupage medium

Miniature glass bottle with cork

Scrap of open-weave cheesecloth

Pages of printed paper

24-gauge/0.5mm copper wire

Round-nose pliers

Small key finding

3 old metal spoons

2 bottle caps

Old photograph

Selection of buttons

Lengths of thread

Scissors

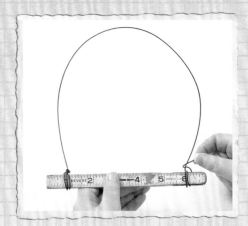

1. Cut a length of the wire about 30in (75cm) long. Coil each end of the wire decoratively around toward each end of the section of rule, creating a large hanging loop in the middle.

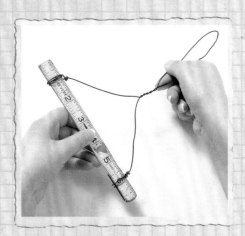

2. Twist the loop of wire together to create a twisted single length, beginning about 2in (5cm) above the rule. Bend the end of the twisted section over into a hook—it should look like a small wire clothes hanger.

3. Measure and mark the center of the rule near the bottom edge on the front surface. Drill a small hole right through the rule at this point, which will be used to hang the central spoon.

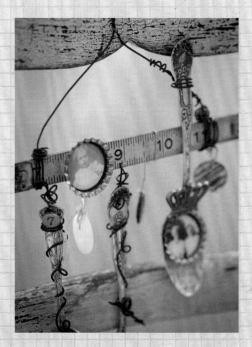

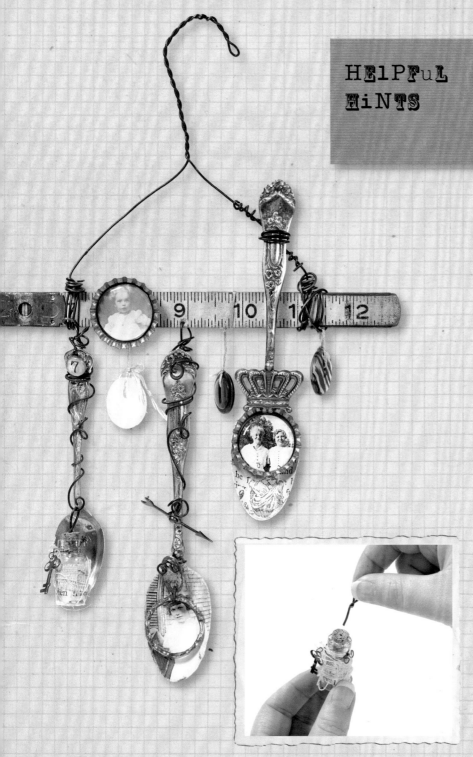

HE1PFuL HiNTS

Look out for odd spoons in thrift stores or at yard sales. You could also just as easily use decorative forks for this project.

Be creative with your decorative embellishments; try typewriter keys, old numbers, or interesting nuts and bolts.

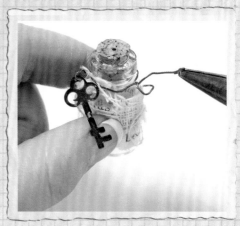

4. Decoupage the bottle with the scrap of paper and the piece of cheesecloth (see page 30). Cut a short length of the copper wire and thread through the key finding. Wrap the wire around the bottle and twist to secure on the back.

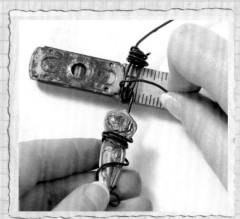

5. Twist a short length of wire into a ring, leaving one long end. Push the end into the cork of the bottle to make a hanging loop. Use lengths of steel wire to wire-wrap the spoons.

6. Wire the spoons to the hanger, one at the end, one at the center and one on the arm of the wire hanger. Hang the bottle at a suitable point. Add bottle cap frames (see page 30) with glue. Thread a double length of thread through a hole of the button and use to hang the button from the rule, tying the ends in a bow.

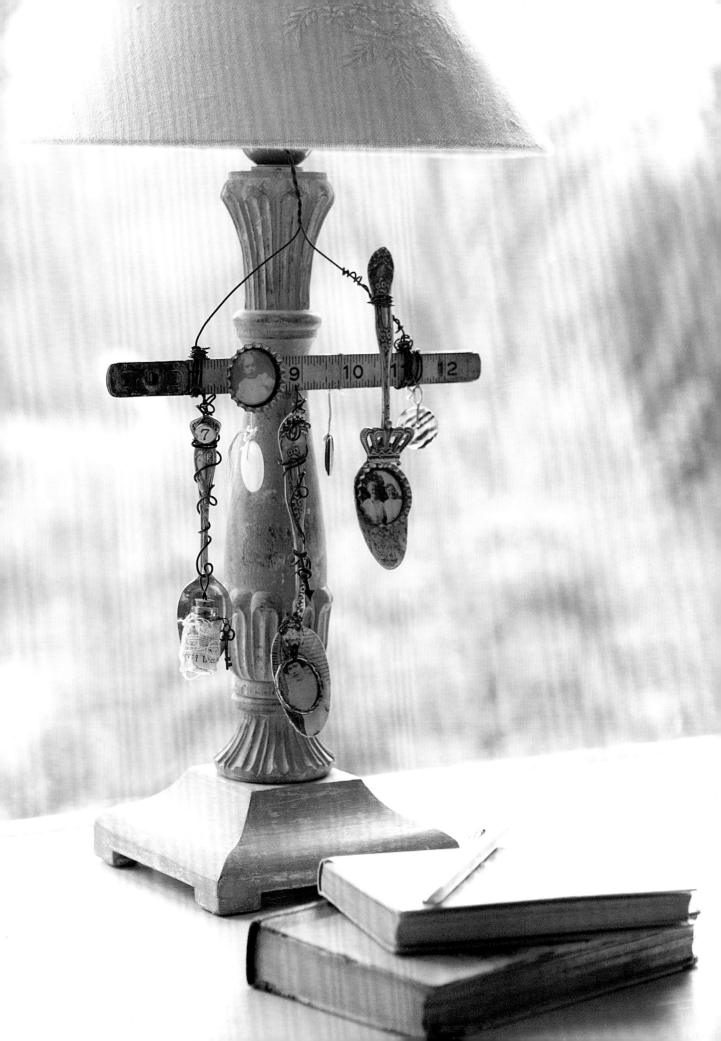

SPrInG OWL

A trip to the flea market revealed two great finds: bedsprings and shoe stretchers! A very odd combination but with such a interesting shape and beautiful patina. This delightfully fun and funky owl with its goggle eyes showcases the marriage of these odd creative objects.

materials

- 19-gauge/0.9mm annealed steel wire
- Wire cutters
- Jewelry pliers
- Metal boot or shoe stretcher
- Two red water faucet knobs
- Small nuts and bolts
- Templates on page 125
- Soda cans with various prints and colors
- Scissors
- ⅛-in (2-mm) round hole punch
- Sticks and twigs
- 24-gauge/0.5mm c opper wire
- Mattress spring
- Silicone-based adhesive
- Two ⅞-in (2-cm) washers

HElPFuL HiNTs

If you can't find exactly the same faucet handles, just substitute something similar that will give the owlish effect.

Let Mother Nature add some of her creative touches by placing the owl in the garden to weather and get better over time.

1. Cut a piece of wire 8in (20cm) long and fold to form a "V" shape. Wrap an additional length of wire a short way up each arm of the "V" to give the beak a little more bulk, leave a long wire end clear on each side. Remove the extension from the shoe stretcher and screw in the faucet knobs as eyes, securing with nuts on the reverse.

2. Place the wire beak between the eyes and wrap the wire ends around the rear pegs of the faucet knob to secure. Cut two 8-in (20-cm) pieces of wire and fold each over off-center to make the ears. Wrap the long ends of each around the back of the rear pegs of the faucet knob to secure.

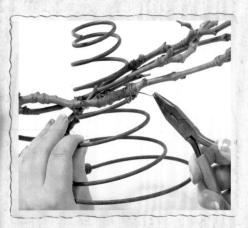

3. Using the template on page 125, cut two wings from soda cans. Punch a hole in the top of each wing and secure on each side of the owl with a nut and bolt. Gather the twigs together and bind in the center with a short length of copper wire. Attach the twigs to the spring with another length of copper wire.

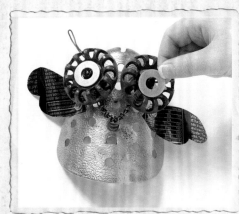

4. Glue one of the washers to the center of each eye. Attach the owl body to the mattress spring with a length of wire—add a little glue if needed to provide additional support.

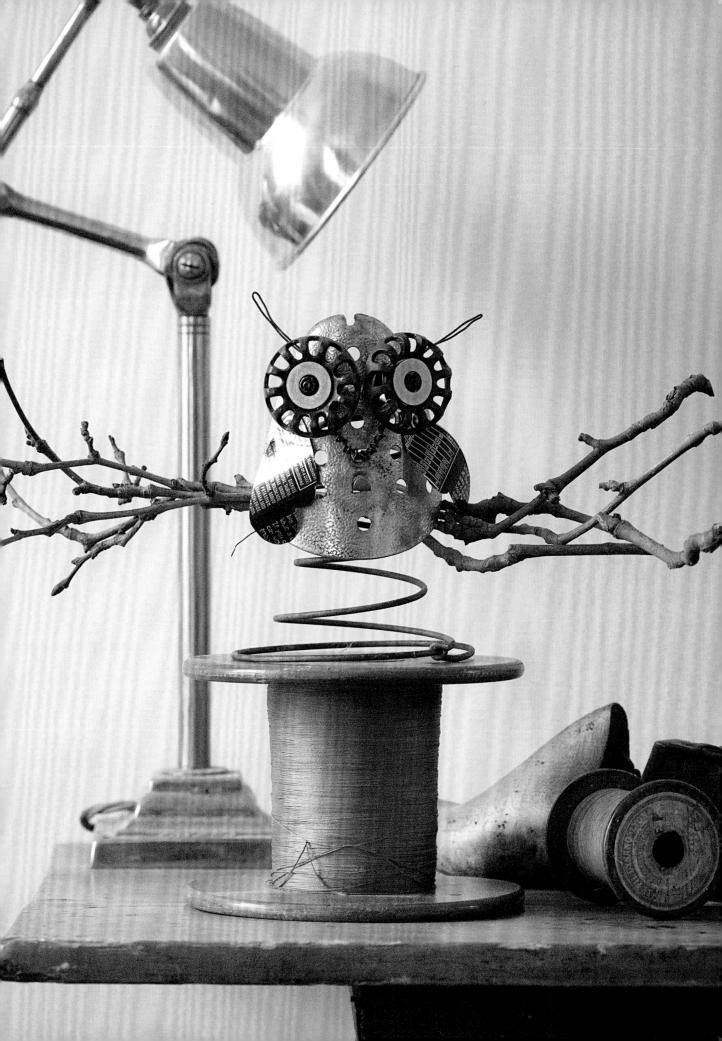

LOve BirDs

I was excited to pick up a bulk of quilting and fabric scraps very inexpensively at a flea market. This project requires some sewing skills, but only really basic stitching so don't let that put you off. Birds and hearts are reccurring motifs throughout history and they go together really well. This heart-and-bird motif is designed to stand on a crystal base—in a sunny window, the crystal will also catch the light.

materials

Paper

Template on page 125

3 x 6-in (7.5 x 15-cm) scrap of chenille fabric

Pins

Scissors

Needle and sewing thread

Small open heart pendant

Fiberfill stuffing

60-in (150-cm) length of 19-gauge annealed steel wire

Wire cutters

Flat-nose pliers

Lace from the end of a handkerchief or doily for wing

Fabric adhesive

Decorative button

Glass knob handle with screw and nut fitting

Large brass flower finding

Short length of cheesecloth

1. Copy the bird template on page 125 onto a piece of paper. Fold the chenille fabric in half and pin on the paper pattern. Carefully cut out the bird shape through both layers of fabric.

2. Remove the pattern. Thread a needle with a length of thread to match the fabric color and overstitch around the outline of the shape, leaving a short length open at the base of the bird.

3. Place a small heart pendant on the back of the bird, so that the tip of the heart sticks over the edge in a beak shape. Stitch in place on the back of the bird, being careful not to stitch through both layers of fabric.

4. Stuff the bird through the hole left in the base, using a little fiberfill stuffing—do not stuff too firmly, just enough to round out the shape nicely.

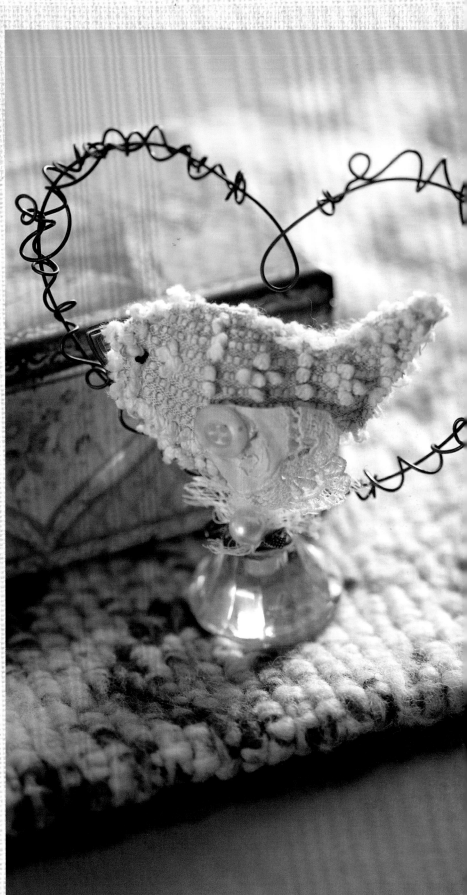

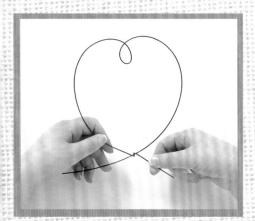

5. Cut a 24-in (60-cm) length of the wire, twist it around into a loop at the center, and then bend the ends into a heart shape, as shown. Twist the ends together to secure, leaving a long end on one side.

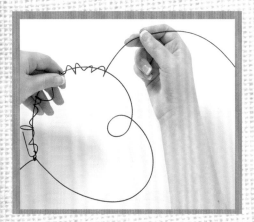

6. Starting near the point of the heart, wrap the remaining wire around the heart randomly to give it a little extra embellishment. Continue all the way around.

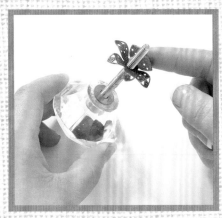

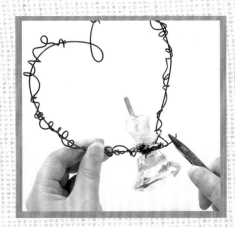

7. Gather the piece of lace trim into a wing shape and glue to the side of the bird. Glue a small button over the top of the wing, where it joins the body.

8. Remove the fixing nut from the threaded shank of the handle. Screw the flower finding down the handle shank until it sits just above the handle itself.

9. Place the wire heart against the shank of the handle and twist the long wire end around between the handle and the flower to secure in place. Wrap the remaining screw above the heart with a short length of cheesecloth.

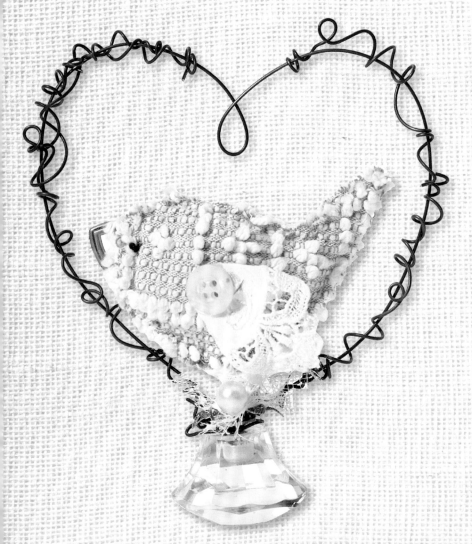

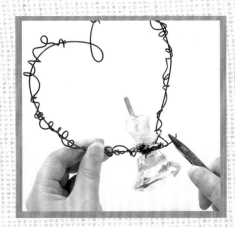

10. Push the screw into the hole left in the base of the bird, so that the bird sits inside the heart shape.

GRaNdFaTHer CLoCk

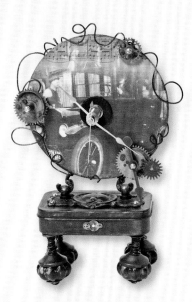

When I was thinking about this project I had in mind to do something with a more masculine feel, using clock gears and darker colors. The idea of a grandfather clock occurred to me and I found this photograph of my grandfather in his first car—so this really is a "grandfather clock"!

materials

- Large Altoid or similar mint tin
- Sanding block
- Acrylic paint in burnt umber, red
- Paintbrush
- Crackle glaze
- Oil-based paint stick in gold
- Cosmetic sponge
- Punch and hammer
- 19-gauge/0.9mm annealed steel wire
- 4 knob drawer pulls with screw threads
- Drawer pull with plate
- 8 nuts
- 4 small screws
- Vintage photograph
- Sheet music
- Decoupage medium
- CD
- Battery-powered clock mechanism
- Craft glue, optional

1. Sand the tin and apply the crackle finish (see page 27), using burnt umber as the base coat and red as the top coat.

2. Apply some gold paint to a cosmetic sponge and lightly add some gold highlighting along the edges.

3. Punch a hole near each corner of the base of the tin for the legs. Punch another four holes in the lid to match the fixing holes in the drawer pull.

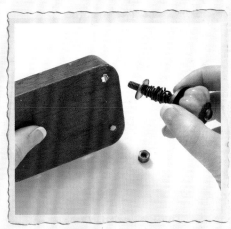

4. Wire wrap halfway along the screw thread of each of the knob handles. Push the screw part of each handle through a hole in the base.

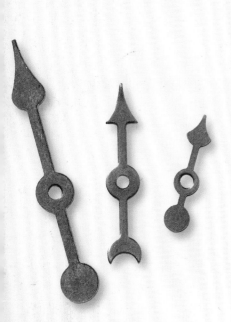

5. Screw a nut onto the screw thread to hold the knob handles in place. Fix the drawer pull onto the lid in the same way.

6. Decoupage the photo and the sheet music to the CD (see page 30). Add the clock mechanism to the back of the CD with the hands on the front.

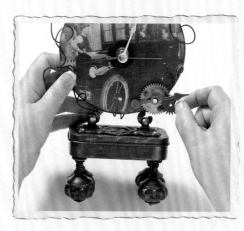

7. Wrap wire around the handle of the drawer pull and create a decoratively twisted wire circle around the same size as the CD to hold the clock face in place. Secure with dabs of glue if necessary.

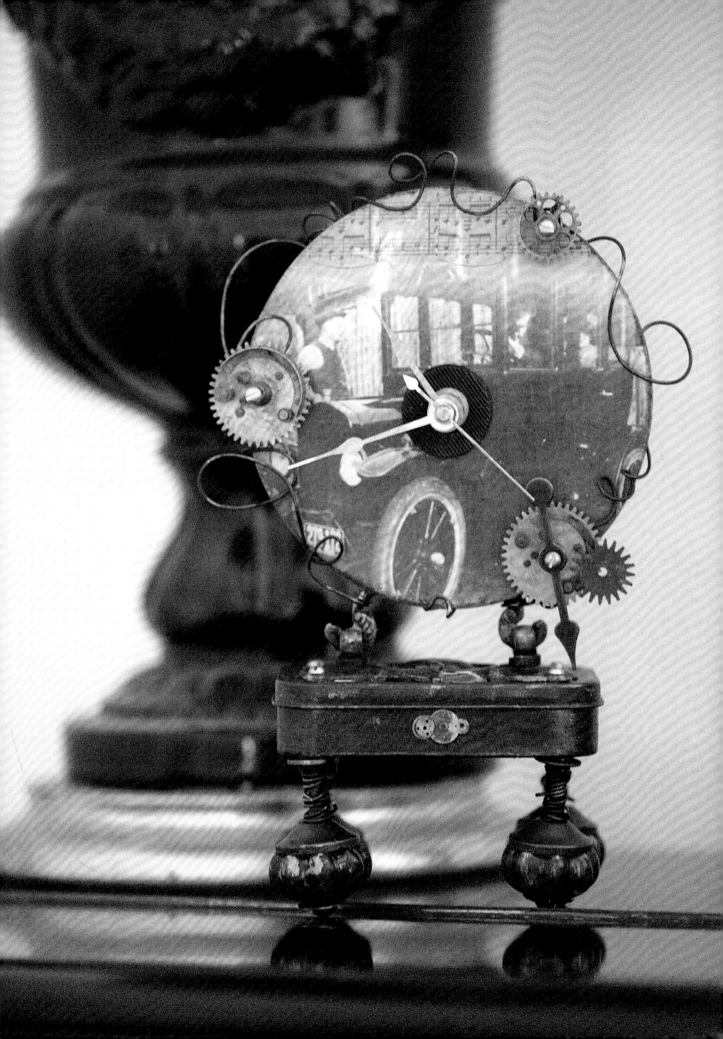

TEmpLaTeS

Here are the templates for projects that require one. They are all shown full size except the turtle for the Beach Tote and the base for the Steampunk Couture Bracelet, which will both need enlarging by 100%. Of course you can adjust the size of any of the templates to suit your own project.

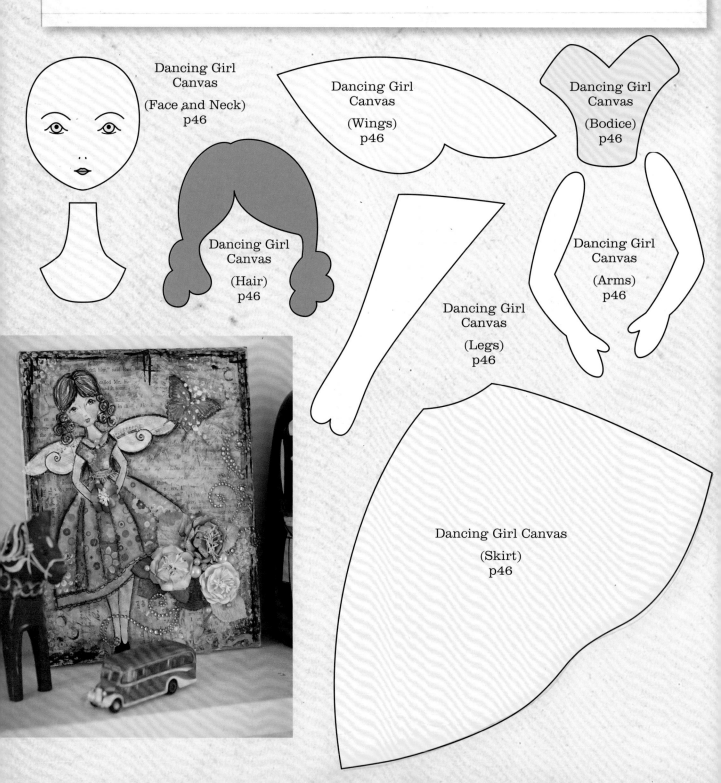

Dancing Girl
Canvas

(Face and Neck)
p46

Dancing Girl
Canvas

(Wings)
p46

Dancing Girl
Canvas

(Bodice)
p46

Dancing Girl
Canvas

(Hair)
p46

Dancing Girl
Canvas

(Arms)
p46

Dancing Girl
Canvas

(Legs)
p46

Dancing Girl Canvas

(Skirt)
p46

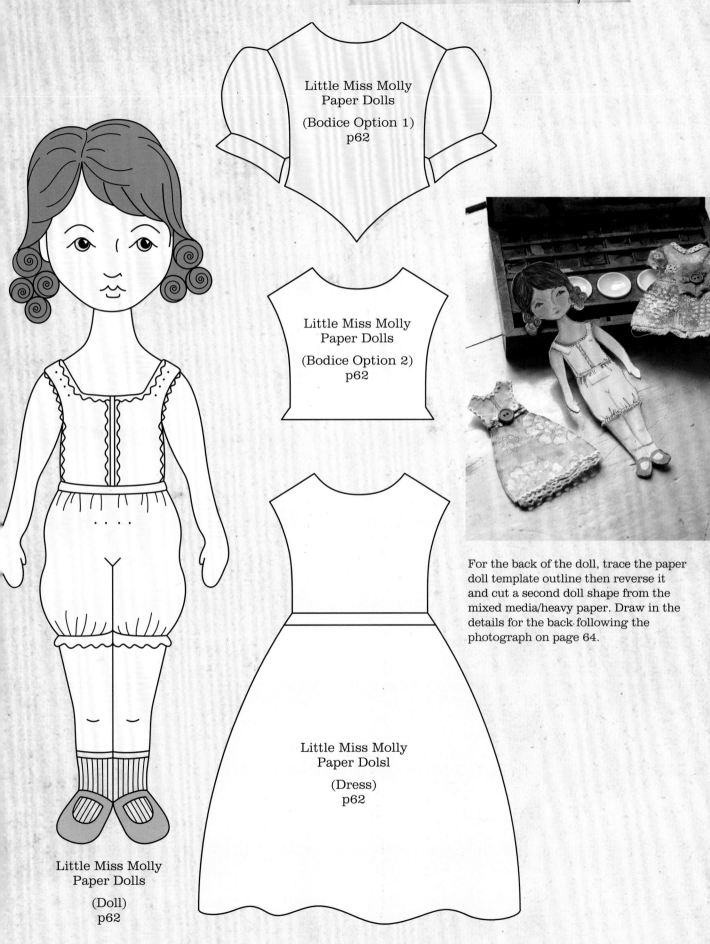

Little Miss Molly
Paper Dolls

(Bodice Option 1)
p62

Little Miss Molly
Paper Dolls

(Bodice Option 2)
p62

For the back of the doll, trace the paper
doll template outline then reverse it
and cut a second doll shape from the
mixed media/heavy paper. Draw in the
details for the back following the
photograph on page 64.

Little Miss Molly
Paper Dolsl

(Dress)
p62

Little Miss Molly
Paper Dolls

(Doll)
p62

Stamped Owl Journal
(Owl Body)

p44

Stamped Owl Journal
(Eyes)

p44

Stamped Owl Journal
(Iris)

p44

Stamped Owl Journal
(Stamp Handle)

p44

Stamped Owl Journal
(Stamp Handle)

p44

Stamped Owl
Journal
(Wings)

p44

Owl Journal
(Handle)

p44

Owl
Journal
(Handle)

p44

Owl
Journal
(Handle)

p44

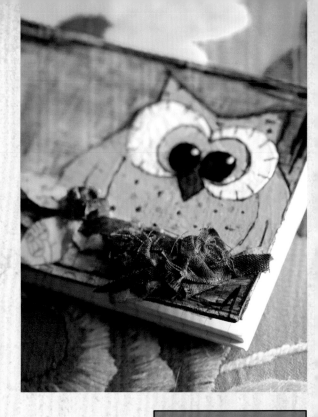

Art Journal Page
(House)

p58

Altered Houses
(House)

p106

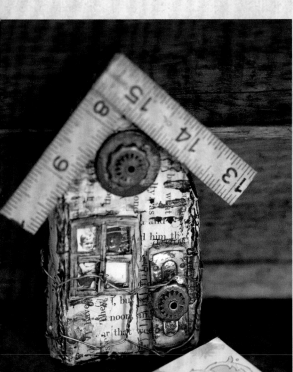

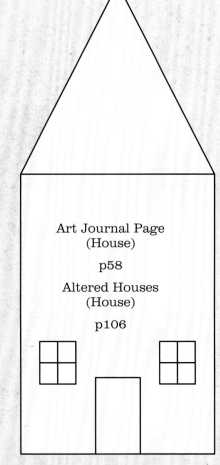

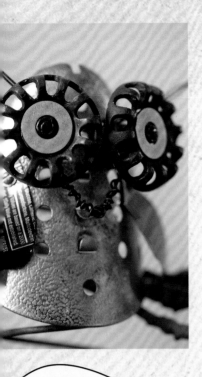

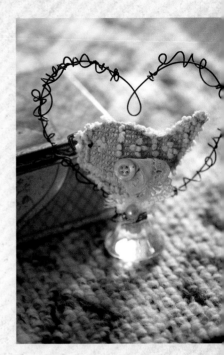

Love Birds
(Bird)

p116

Leave open
between
marks for
stuffing.

Stitch heart pendant for beak
as indicated by arrows.

Spring Owl
(Wing)

p114

Beach Tote
(Turtle)
(enlarge by 100%)

p74

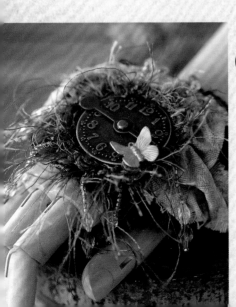

Steampunk Couture
Bracelet
(Fabric Base)
(enlarge by 100%)

p82

REsoUrCeS

Linda Peterson
Linda Peterson Designs
www.lindapetersondesigns.com
lindapetersondesigns@yahoo.com

US SUPPLIERS
GENERAL CRAFT
Craft materials and tools.

Hobby Lobby Stores
www.hobbylobby.com

Michaels Stores
www.michaels.com

A.C. Moore
www.acmoore.com

JoAnn Crafts
www.joann.com

HARDWARE SUPPLIERS
Specialty nuts, bolts, and copper
sheeting and pipe.

Ace Hardware
www.acehardware.com

Lowe's Inc.
www.lowes.com

Home Depot
www.homedepot.com

OTHER MATERIALS
Other materials used in the projects.

Acrylic Paints and Crackle Medium
Plaid Enterprises
www.plaidonline.com

**Collage Pauge Decoupage Medium
and Adhesives**
iLovetoCreate
www.ilovetocreate.com

**Rub-N-Buff®, ArtEmboss®,
WireForm®, and Friendly Plastic®**
Amaco., Inc.
www.amaco.com

**Basic Jewelry Findings, Chains,
and Leather Cording**
Beadalon, Inc.
www.beadalon.com

Paintbrushes
Royal Lagnickel
www.royalbrush.com

**Alcohol Inks, Distressing Ink,
and Color Wash**
Ranger Inc.
www.rangerink.com

Gesso, Art Canvases, Chipboard
www.jackricheson.com

Drawing Pencils, Charcoal
General Pencil Co., Inc.
www.generalpencil.com

UK SUPPLIERS
GENERAL CRAFT
Craft materials and tools.

Hobbycraft
Stores nationwide, call 0800 0272387
www.hobbycraft.co.uk

Crafty Devils
Online store
www.craftydevilspapercraft.co.uk

John Lewis
Stores nationwide
www.johnlewis.com

The Craft Barn
Online store
www.thecraftbarn.co.uk

HARDWARE SUPPLIERS
Specialty nuts, bolts, and copper
sheeting and pipe.

B&Q
Stores nationwide
www.diy.com

Scientific Wire Company
www.wires.co.uk

OTHER MATERIALS
Other materials used in the projects.

Friendly Plastic® and Rub-N-Buff®
Pottery Crafts
www.potterycrafts.co.uk

Beads and Charms
The Bead Shop
www.the-beadshop.co.uk

**Basic Jewelry Findings, Beads, and
Leather Cording**
Bead Crafty
01274 666013
www.beadcrafty.com

**Jewelry Findings, Tools, Wire,
Chains, and Beads**
Bellore
www.bellore.co.uk

Art supplies, canvases, brushes
London Graphic Centre
Three stores in central London
www.londongraphics.co.uk

Cass Art London
Five stores in central London
www.cassart.co.uk

ACknOwLeDgMeNtS

Just as they say it takes a town to raise a child, it takes a great team to create a book! While I may be the name on the front cover, this book is not possible without the help of my great team—my publisher, Cindy Richards, and her talented team of Sally and Dawn; my personal editor, Marie Clayton, who spent endless hours poring over my words; my photographer, Geoff Dann, who is brilliant at making my work shine, and his assistant, Marc Harvey, my project stylist, Luis Peral-Aranda and style photographer, Gavin Kingcome. Another vital member of the team is Mariah Welsh, the very patient hand model for all the step-by-step shots. Thank you all for each of your talents and efforts into creating this book! You are the best!

I also have to thank my family: my husband, Dana, and kids for jumping in and getting things done while I poured my soul into this book. This is a sacrifice of love from you to me. I love you all!

DEDICATION

This book is dedicated to my Mother, Jane Molden, who recently lost her battle with cancer after many years. She was a beautiful person in every way, and an excellent example of a Wife, Mother, and Friend. Thank you, Mom, for all you have given to me. I love you! Until we meet again!

INdeX